Open Conversations

Open Conversations

Strategies for Professional
Development in Museums

Carolyn P. Blackmon
Project Director and Chairman,
Department of Education

Teresa K. LaMaster
Project Coordinator

Lisa C. Roberts
Researcher/Writer

Beverly Serrell
Evaluator

Department of Education
Field Museum of Natural History
Chicago, Illinois

This publication is made possible in part through
the generosity of the W.K. Kellogg Foundation.

Library of Congress Catalog Number 88-80568

ISBN 0-914868-10-1

Edited by Ellen Cochran Hirzy
Designed by Lynn Hobbs
Illustrated by Linda Kelen

Copies of this book are available from:
Department of Education
Field Museum of Natural History
Roosevelt Road at Lake Shore Drive
Chicago, Illinois 60605
(312) 922-9410

To our Kellogg Project participants, reflective professionals whose open conversations enriched this book immeasurably

Contents

Preface

This is a new chapter in a "book" that will never be finished. As they emerge, all of these writings not only examine issues, but continue to document the evolution and clarify the significance of museums—their collections and programs, policies and governance, management and personnel practices, marketing and fund raising.

This new chapter grew out of the deluge of inquiries and requests for assistance directed to Field Museum. Museum practitioners across the country and around the world, at the entry level and beyond, are concerned about everything from procedural and technical questions to practical job needs to issues of management, philosophy, and professional ethics. This chapter also grew out of the dialogue led by the American Association of Museums Standing Professional Committee on Education during the early 1980s. Educators debated the state of

museum education, the nature of museums as learning environments, and the responsibilities, mission, and goals of museums. The concerns that surfaced included the necessity of a theoretical base for museum education; the need for greater awareness and understanding of museum audiences and especially their non-audiences; the value of learning from and collaborating with other educational institutions; and the desirability for training to increase educators' subject-based knowledge and develop their ability to communicate such skills as object-based thinking and learning. These are all issues that can help us begin to analyze the "personality" of a museum and, more important, move forward to reflect on and articulate its mission.

In this context in the fall of 1982, Field Museum of Natural History initiated a project supported by the W. K. Kellogg Foundation called *Museums: Agents for Public*

Education. Our original goals were concerned with staff-initiated opportunities for personal growth; administrative level museum/school collaboration; strategies for educational programming that accommodate diverse visitor learning styles; and the team approach to program and exhibit development. As the project evolved, we were able to expand on our original commitment to "outline and provide forums to discuss and disseminate ideas, provide technical assistance with practical application, and promote philosophical discussion."

This new chapter—*Open Conversations: Strategies for Professional Development in Museums*—is the synthesis of Field Museum's interactions, explorations, and discoveries with 500 museum professionals from more than 300 institutions. This is their pub-

lication, because each of them has made an active contribution to its messages and its shape. Many others shared in the architecture of the Kellogg project. The staff and administrators of Field Museum, the W.K. Kellogg Foundation directors, museum colleagues and resource people in the community and around the country, all have been interested and often challenging supporters. They have our deepest appreciation for their collaboration and their vision.

In *Catalysts for Change,* an interim report on the Kellogg Projects in Museum Education, Mary Ellen Munley described the projects' impact:

> The Commission on Museums for a New Century concluded that museums have yet to realize their full potential as educational institutions. The commission suggested that new approaches to learning in museums must be developed. The lessons embedded in the Kellogg Projects. . .offer several new approaches to learning in museums that should be

of interest to the entire museum community. . . . It is no longer sufficient to talk about museums as having the capacity to provide enrichment for people of all ages, and the time has long since passed when a museum's educational value could be simply taken for granted—and essentially ignored. The Kellogg Projects are guiding hundreds of museums, and thousands of museum professionals, beyond talk. . . . Dreamed-of ideals are becoming concrete objectives and programs.

Our conversations with museum professionals in the Kellogg workshops revealed that we share five goals:

▶ To make objects and the ideas they represent approachable.

▶ To create a positive and enjoyable experience for our visitors.

▶ To increase intellectual accessibility by producing a focused yet ambient learning environment.

▶ To direct attention to the unique characteristics of our objects, their meanings and their realness.

▶ To foster curiosity, exploration, and discovery in our visitors.

We invite you to breathe more life into this "chapter" by trying it on for size and by turning some of these goals—and your own dreamed-of ideals—into reality.

C.P.B.
T.K.L.
L.C.R.
B.S.

Acknowledgements

The Field Museum Kellogg Project began as a groundbreaking experiment to expand the educational potential of museums. This publication is the final phase of that experiment, a contribution from the profession intended to help fuel the conversations that began six years ago and provide continuing professional development experiences for museum people. As we at Field Museum have taught, so have we learned. We are indebted to the work of hundreds of people whose talents and ideas helped shape this publication.

We are grateful to the W. K. Kellogg Foundation for their generous support of this project and their commitment to developing leaders in the museum profession.

Maxine Gaiber was coordinator for the first year of the Kellogg Project, and we thank her for her development of the initial project curriculum. Helen Voris, our researcher/writer for four years, contributed organizational and writing talents that were critical to the project's success. More important, her many inventive ideas immeasurably enriched the project curriculum.

Our editor, Ellen Hirzy, and our designer, Lynn Hobbs, both worked under tight deadlines with tremendous patience, cooperation, and creativity. Ellen's clear understanding of the challenges facing museums contributed greatly to the content and structure of this publication, and Lynn's keen sense of the relationship between function and design enhanced its readability.

All the members of the Field Museum Education Department staff were generous with their advice, encouragement, and support. Norann Miller, department secretary, has our special thanks for her work with the organizational phases of the project. It ran smoothly as a result of her attention to detail and her many useful ideas.

Linda Kelen's illustrations give this book an added creative dimension. Print/production coordinator Pam Sterns helped us see the publication through to completion. Bob Feldman gave generously of his time, helping us through the numerous computer "glitches" that come with a project of this scope. Sue Rizzo worked diligently as our proofreader. As facilitator for

the Kellogg Project Colloquia, Lynn Young-blood, Vice President of the University of Indianapolis, drew from the participants valuable ideas and observations that are evident throughout these pages.

Many museum professionals from throughout the country have enriched the conversations of the Kellogg Project. Some served as faculty, developing activities that have been incorporated into this publication. Others were workshop participants representing more than 300 institutions. Still others graciously hosted site visits to help us evaluate the impact of the project. And, finally, 50 workshop alumni and 12

Field Museum staff came together for two colloquia held in November and December 1987. They reviewed a draft manuscript for this publication, contributed the portions of the text called "Voices from the Field," and gave us sound advice about making *Open Conversations* a useful guide for professional development.

Introduction

The fundamental encounter between a museum and its public occurs in the presentation and interpretation of objects. Today this encounter is under more thorough scrutiny than ever in the past as we explore the many opportunities involved in linking visitors and objects. In part as a product of our inquiry, there has been an explosion of creativity and improvisation in public programming. The halls of museums are filled with familiar objects in different contexts, new kinds of objects, and innovative methods of encountering both. As museum staff, we have renewed our commitment to understanding and serving our visitors' interests and needs.

At the same time, museums are feeling the pressures of limited resources, competition from other leisure activities, and the increasing diversity of our audience. We are realizing that serving our public involves more than developing a flurry of exhibits and programs. It requires learning to set priorities and manage our resources effectively and creatively. As we develop these skills we are assessing

▶ the strengths of our institutions and departments;

▶ the unique possibilities inherent in our collections;

▶ the interests and abilities of our visitors; and

▶ the expertise and responsibility of our staff.

The goal of the Kellogg Project at Field Museum of Natural History has been to explore these and other issues by discussing strategies for the presentation and interpretation of objects through exhibits and programs. This book is the result of our exploration.

Everyone who participated in its creation felt deeply the challenge of writing something broad enough to be applicable in a variety of museums, but focused enough to be of practical, serviceable value. From the start, we wanted to link the theoretical and the practical sides of museum work. The result is a guide that aims not to provide definitive answers, but to offer a means by which readers may find the answers that work for them—a guide for thoughtful conversation.

Open Conversations is organized around the three fundamental elements of the museum encounter: the institution, the audience, and the staff who bring the two together. True to the museum spirit, the book draws on many styles of thinking. Each chapter is structured

around a short narrative which sketches out a series of issues facing the museum profession. These issues are expanded upon in the form of short essays, case studies and exercises written by colloquia participants and appear on shaded pages titled, "Voices from the Field". Activities at the end of each chapter—marked by a bar at the top of the page—are designed to help further explore the issues introduced in the text.

While this book can be used and contemplated alone, it is our hope that it will also be used by groups. Museum staff, conference participants, and museum studies students may all view this book as a tool for thought and communication. Staff might find it useful, for example, to do an activity or discuss a chapter together as part of a monthly staff meeting. Local museums might treat the book as an opportunity for collaboration and professional exchange among their staffs.

But, most important, we hope readers will treat this book as a tool in the fullest sense of the word. It is both testament and stimulant to open conversation, both product and continuation of our inquiry into the fundamental encounter between the museum and the visitor: Write in it, photocopy it, curse in its margins. It is *meant* to be dog-eared. We welcome any comments you would like to share about how you used this guide and how well it works for you.

The Institution

*Understanding the Museum's
Unique Mission*

Institutional Mission

The mission of a museum is its guiding statement of purpose. It describes why the institution exists, what its overarching functions are, and what the scope of its activities should be. It serves as the foundation for action within the museum. Every decision about policy or program—from exhibit development to directions in research to fund raising—must relate to and support the institution's mission. Mission is the place where planning and assessment begin.

Most missions are expressed in fairly broad terms that reflect the traditional purposes of museums. They commonly include some description of the institution's subject matter and charge such functions as acquiring and preserving objects, conducting research, and providing public education programs. These tenets define the basic values of a museum. They place it within the context of the larger museum community while distinguishing it from other public institutions like universities, libraries, and civic arts organizations.

The fundamental responsibility of a museum's staff is to interpret and make concrete their common mission. The implementation of mission through department, program, and exhibit goals is what establishes the "personality" of a museum and sets it apart from others. One factor that affects the way we interpret and express our museum's mission is our personal value systems. Personal values shape our understanding of our work; they influence the way we define goals, set priorities, focus energy, and make choices. They leave a public mark on exhibits and programs, and they can have a strong impact on museum audiences. An awareness of the nature and role of individual values is important to our interpretation of institutional mission.

A museum's mission statement is its guiding statement of purpose.

The interpretation and implementation of mission are at the heart of many institutional conflicts. Conflicts that occur in a museum—whether they relate to budget allocations or to the design of this year's visitor guide—often originate from misunderstandings over our interpretation of mission. There are two major kinds of conflicts over mission:

▶ *Conflicts over commitment* have to do with the role of mission in institutional operations. Too often, a mission statement is rarely discussed or revised, and it is allowed to become a dusty old document that nobody reads. Then mission no longer serves as the basis for action, and decisions are guided less by a common vision than by personal interest, current trends, or available resources. As a result, the overall vision of the institution can be easily fragmented.

▶ *Conflicts over clarity* have to do with how mission is interpreted. Competing interpretations may arise as a result of differences in the staff's personal value systems. Particularly as society changes, many staff

Conflict over mission is at the heart of many institutional problems.

begin to rethink the institution's role and the kinds of exhibitions, programs, and activities it ought to undertake.

As staff, our commitment to and interpretation of our museum's mission are manifested in the goals and objectives we formulate. When problems arise over the direction a project should be taking or the means by which it can best be implemented, it is useful to examine the assumptions that stand behind differing perceptions and views. Structural problems, methodological differences, and misconstrued goals are often symptoms of a deeper conflict over the meaning of the museum's mission.

Activity 1, *An Organization's Dimensions*, is an exercise in identifying the origins of conflict.

A good example of conflict over mission is the struggle about the extent to which museums should respond to the conditions of modern life. Some people argue that since museums reflect and serve a complex and diverse society, museum staffs must be sensitive to society's special qualities and challenges if we are to carry out our institutions' missions in a responsible and timely way. Since public use of museums is in large part both voluntary and informal, this sensitivity becomes especially important, for the societal climate shapes what is applicable, intelligible, and worthwhile to the visitor's experience. Understanding what is relevant to our audiences can only help us attract the casual, voluntary visitor to our museums. Museum professionals are grappling with and responding to a number of issues in order to develop present-day interpretations of their museums' missions.

Many museums are struggling with ways to implement their mission through long-range plans.

▶ *Preservation.* Collecting has traditionally been at the heart of museum activities. Over the centuries, many different criteria have affected decisions about acquiring objects. Conditions in today's society have caused us to think about this function in new ways. Museums are increasingly serving a corrective function in preserving our disappearing heritage. Mass production has led to a profusion of disposable goods, and as a result our material culture turns over with enormous speed and frequency. Economic and

geopolitical forces have had a dramatic global impact on environmental stability and led to an unparalleled extinction rate among plant and animal species. What is the nature of museums' responsibility to the survival of the physical world, be it cultural or natural? Do we preserve in order to educate? to remind? What determines the limits to museums' capacity to collect? In what ways do our institutional goals affect our policies for deciding what to collect? In what ways do our collecting goals influence the goals of our public presentations?

▶ *Social argument.* Some museums interpret their public educational function to include the presentation of potentially controversial social, ethical, or intellectual issues. Exhibitions of Ku Klux Klan history, the pros and cons of nuclear energy, and dinner plates by Judy Chicago and a collective of other women artists have all required careful decisions about the nature of the objects and ideas being presented. Can museums contribute to social argument without advocating a particular stand? Can they remain neutral in such a role, even while trying to inform? Should they? Why or why not?

Activity 2, *An Advocacy Role for Museums?*, poses the hypothetical case of a museum director faced with difficult choices about the museum's role in controversial social argument.

Should museums play an advocacy role on current social issues?

▶ *Education.* Informal, voluntary modes of education have gained enormous credibility and popularity among people of all ages. A highly educated population of baby boomers has the inclination and the spending power to make learning a lifelong process, while a generation of retirees is looking for productive ways to spend their leisure time. At the same time, the nation's educational system, from elementary school through the university, has come under severe fire, and

reformers are examining opportunities for cooperation with alternative educational institutions. How can museums serve society's changing educational needs? What limits their involvement? Can they exert leadership in educational affairs? Should they? What might their role be?

▶ *Personal orientation.* Contemporary society legitimizes alternative lifestyles, family structures, sex roles, and workplaces. Values that emphasize personal fulfillment and individual judgment have come to supplant traditional sources of authority like the church and the family. In this environment, the individual must struggle to define his or her own roles and signposts in the search for meaning and direction in life. What can

museums contribute to this personal quest? How do objects of history and art, science and nature, inspire people's search for identity, stability, and continuity?

▶ *Community involvement.* Museum collections exemplify a cultural and ideological diversity that is seldom represented in the makeup of their audiences or their staffs. Museums are perceived as showcases, when they should be seen as bridge-builders. As caretakers of virtually everyone's heritage, museums are in a position to address the cultural diversity that has fragmented our communities. What would such a responsibility entail? How can museums promote communication and strengthen community

ties? How should museums' response to the question today differ from their response through the outreach efforts of the 1960s and 1970s?

Our attitudes toward all of these issues color our interpretation of the traditional mission of museums, and many of them cause us to tread on what has typically been considered politically sensitive ground for our institutions. Conflict over appropriate ways of promoting greater social responsibility and institutional involvement is fundamentally conflict over the limits and leeway within which mission is being interpreted.

Resolving conflict involves recognizing its connection to mission and values.
Sometimes competing perspectives can serve a positive function by stimulating creative thought and balanced decision-making. But when conflict prevents consensus, it is time

to examine the interpretations and assumptions underlying the competing perspectives. Conflict is often more deeply rooted than it appears to be. When there is conflict, our responsibility as staff is to ask questions—of ourselves and of museum management—to clarify our interpretation of mission and our role in upholding it. In turn, management's responsibility in conflict situations is to help guide staff toward understanding, implementing, and achieving a common purpose by giving them a clear picture of the institutional vision.

7

Voices from the Field

Museum Education and the Influence of the Marketplace

In the past two decades we have witnessed the phenomenon of the museum aggressively positioning itself within the American market society. Writing in *Museum News* (June 1985), Paul DiMaggio defined the driving forces of the marketplace: the competition for gain, the precise calculation of benefits and losses, the survival of the economically fit, and the expiration of organizations that fail on the bottom line. Museums reflect the "rhetoric of means and numbers," to borrow DiMaggio's term, in several ways. Blockbuster exhibitions, the museum's equivalent of mass commercial entertainment, are proliferating. New staff positions for marketing, corporate affairs and audience development are being created. Profit centers such as shops or restaurants are being built within the organization. Museums are assiduously wooing corporations and businesses for subsidies, with the promise of spin-off benefits such as image enhancing and direct contact with high-profile target markets. And, finally, boards of trustees now include a fair number of influential representatives from industry and business along with the more traditional collectors, long-time volunteers, and philanthropists.

The American museum's increasingly sophisticated responses to the marketplace have on the whole been necessary to guarantee long-term institutional stability. But applying market standards as the exclusive measurement of our work can ultimately compromise the integrity of our museums. A healthy balance needs to be achieved. Yet many museums frequently lose sight of their stated missions while honing their competitive instincts, and the implications are staggering. Are the most successful education programs those whose revenues bear the largest economic multipliers, attract the largest number of upper-demographic participants, or consistently gain the favor of the local corporation? Most museum educators would emphatically say no, recognizing that some programs need to be insulated and protected from market forces. These include programs that engage or encourage the interest of low-income populations, the elderly, schoolchildren, and others who do not have the ability to pay; programs that deal with aspects of the collections that are relatively unfamiliar to the public or to which they even may be hostile; programs that address new scholarship with little appeal for the layperson; or programs that risk potential controversy. Beyond this, most educators believe that even programs that generate a good deal of revenue cannot be judged successful in those terms alone.

As museum educators, we work from the belief that museums can have a transforming influence in the lives of the people we serve and that through exhibitions and programs we can shape aesthetic and moral values and contribute to building a civilizing society. We tenaciously cling to lofty ideals such as beauty, truth, creative spirit, empowerment or self-awareness, ideals we feel can be illuminated through exposure to and greater

understanding of a museum's collections. But to the business executive or lawyer who sits on the board, these well-intended goals mean little. Even for those of us in the profession, these noble objectives can begin to ring a little hollow. For in the end, it is not enough to say that the work of art has the ability to shape the experience of the competent viewer and contribute to the well-being of the community. We must prove this notion or quantify it in more precise terms. How do we accurately explain what and how visitors learn and what ideas are most likely to transfer from the objects to daily life? What real impact do we have in fostering new perceptions and attitudes? Until we develop a new vocabulary for response to these questions, we will be increasingly subjugated to the influences of the marketplace within the museum, and our most cherished assumptions about museum education will be sorely challenged in the years ahead.

Ellen Dugan,
High Museum of Art

Museums must balance the concerns of the marketplace with their educational mission.

Voices from the Field

Intrinsic vs. Temporal Values: A Difficult Balancing Act for Museums

Museums embody the hopes, aspirations, ideals—and sometimes the prejudices and cruelties—of the people who created them and the people who operate or use them today. Some of the values museums promote are fundamental and timeless, while others may change as society evolves.

At the Kellogg Project Colloquium in December 1987, a diverse group of museum professionals set out to identify and articulate these values. When it came to the fundamental values—the unchanging principles underlying the purpose and function of museums—there was little dissent. We agreed that:

▶ *Museums promote critical thinking.* They stimulate our ability to evaluate, to compare, to observe carefully, and to ask questions about our experience.

▶ *Museums enhance open-mindedness.* They encourage us to be receptive to other cultures and creatures and to respect human diversity and the range of creative expression.

▶ *Museums sensitize us to the power of objects.* Objects express things about the human experience that cannot be expressed in words, but that enrich our lives by delighting, angering, saddening, overwhelming, or otherwise touching us.

Much more difficult to define and settle upon are questions about the contemporary values and activities of museums. Do museums embrace more limited, temporal purposes? Should they? This raises an array of questions:

▶ *Should museums play an advocacy role?* If so, on what kinds of issues? Should this be a regular practice or an adjunct to other activities? What obligation do museums have to remain objective and present balanced viewpoints? Should political concerns transcend aesthetic or educational concerns?

▶ *Can we serve an advocacy role if it does not relate to our mission statement?* Is the mission statement a departure point or a defining framework for our scope and role? Can the museum's receptivity to addressing contemporary issues be stated elsewhere—perhaps in annual or long-range goals and objectives? How do we arrive at this kind of statement, especially given the often emotion-charged and controversial nature of the issues involved?

▶ *Is a museum's mission statement fixed, or can it be revised?* By what process can it be changed? Who is its custodian? Should it be changed to accommodate a particular societal issue or pressure? What are the inherent possibilities and constraints in changing a mission statement? What are the dangers and benefits? When the language of a mission statement is vague, does it adequately serve to determine the orientation of the institution and guide the institution's response to current societal pressures? Or is vague language best?

Whatever the mission statement, the programs and exhibitions in museums send messages—both subliminal and deliberate—to the public about what the institution and its staff consider worthwhile or important. The traditional, constant values of museums and their contemporary, temporal values are indeed somewhat different. But the temporal values may simply amplify and specify what the intrinsic values have always been.

We devised Activity 2, *An Advocacy Role for Museums?* as an exercise in sorting out the relationship between intrinsic and temporal values. Then we tested the activity with our colleagues at the Kellogg Colloquium. In small groups, they acted out a scenario involving a director and trustees who face a sensitive and potentially volatile situation that brings to the fore the issue of the museum as advocate. The group dynamics reflected everything from heated discussion to embarrassed silence to hesitation in coping with a situation that would surely anger some constituents, whatever the outcome. Their solutions to the hypothetical situation were just as diverse: One of the groups advocated making a strong social statement, while another was unable to act at all.

Our mythical museum exemplifies a dilemma many of us struggle with: reconciling the morally and socially repugnant behavior or lifestyles of the creators of some objects with the humanistic values implicit in museums. Perhaps we need to ask ourselves a few more questions to probe more deeply what museums are all about. If we were to exclude works by artists who hold objectionable opinions or products of societies with values contrary to our own,

what would be left for museums to show? The ancient Greeks all but institutionalized the practice of pederasty; the Romans were only slightly more aware of women's rights than the Greeks; most people in medieval times lived in wretched poverty under feudal oppression; most male artists from any era appear to have been misogynists; and any number of societies and individuals held attitudes about race or gender that we find unacceptable today.

Would we decide not to attend an opera by Richard Wagner because he led an appallingly amoral life? Would we refuse to visit the Louvre because many of its treasures are the spoils of war? Would we boycott the British Museum because many of its objects come from societies and cultures that legitimized slavery and tyranny? If we answer, "of course not", is it merely because these people and cultures are now dead, and this makes it easier to avoid confronting similar situations today?

The problem is graver than it first appears. If one is to firmly and directly connect questions of ethics to the objects shown in museums, the problem goes well beyond the current issues of whether to return sacred

Indian remains, whether to show works that condone the trivialization of women, or how racial and class biases affect our exhibitions and interpretive programming. There isn't much that is ethically acceptable to show if one believes that displaying an object constitutes an endorsement of the character or lifestyle of its creator.

We suspect that none of us would want to deprive ourselves and future generations of contact with the masterworks of human history that are in our care. Despite the circumstances of their creation, the objects we hold in trust are often works of power and beauty, illuminating some important aspects of the human situation. They tap into a creative energy that transcends the flaws or failures of one life or one society.

Students of the creative process believe that creation occurs at a level deeper than the consciousness of the self, even below the level of what we would call personality. Many artists speak of their best work as "given" to them from a source that feels outside themselves. This may be a clue to the

mystery of how masterworks are able to endure and reach across radical changes in history and society to touch us today: They come from and speak to a level that transcends individual personalities and time periods.

Museum mission statements sometimes describe the basic purpose of museums as to create new insights or to delight. Museums are places for us to revert to our old, animistic selves. Museum objects have the power and vitality to reach us at an elemental level.

This encounter, so radically different from the nature of our everyday concerns, creates a sense of delight in life and a reverence for its richness. We in museums are not turning our backs on the world by saying, "We agree with your position, but we're in the business of upholding values of meditation and reverie that enable the visitor to reach into that elemental level." Perhaps the ultimate victory of evil occurs when we are convinced that the world is too damaged, too flawed to allow this kind of encounter. Museums have an equivocal place in society as a result. If we thoroughly offend our publics, then we

have lost. Still, we must understand what we are losing when we decide to censor our exhibitions and programs for social considerations. We have a balancing act to perform, and a full consciousness of the ramifications and the implications will help us perform it.

Mary Cummings,
Missoula Museum of the Arts

Susan Curran,
Field Museum of Natural History

Ellen Dugan,
High Museum of Art

Audrey Janet Olson,
Roswell Museum and Art Center

Jean Robertson,
Columbus Museum of Art

Carol Bruce Shannon,
*City of Colorado Springs
Pioneers' Museum*

Museums must consider both sides of the museum/visitor equation.

Voices from the Field

The Transparent Curtain

When Charles Willson Peale raised the curtain on his "Repository of Natural Curiosities," he awakened America's fascination with museums. In his famous painting, *The Artist in His Museum,* the heavy curtain is lifted seductively to permit a glimpse of the exotic world within. Peale's museum is fashionably hidden behind its velvet barrier.

Let's update this vision. In our contemporary museum, the sense of wonder is still intact. The lifted curtain admits a diversified audience—seniors and school kids, yuppies and punksters, the elite and the not-so-elite, fifth-generation and first-generation Americans, singles and families of all definitions. The collections have grown and are augmented by videos, catalogues, loan kits, slides, films, lectures, classes, and assorted docents.

But the most dramatic change of all is that the velvet barrier is gone. In its place, a transparent curtain hangs as a new symbol. Through it the world enters the museum and the museum enters the world. The transparent curtain reveals an open exchange. Today's museum is positioned in a world that also demands to be seen.

These four case studies reflect how today's museum responds to society.

Seattle Aquarium
Responding to Change and Controversy

Problem/Need: In 1985, growing environmental problems in Puget Sound demanded attention. Confusion and controversy about these problems—their source and their solution—were rampant. Although the scientific community was generating much information, little of it was readily accessible to the public who would ultimately bear the clean-up costs. The aquarium was challenged to take an active educational role.

The Museum Responds: Guided by our mission statement, which mandates that we educate the public about the marine environment, we entered a new and more political arena. We faced some creative challenges: How can we make the "bad news" about pollution, sewage treatment, and dredge disposal interesting? How can we create an exhibit without a collection of animals in an institution where animals are expected to be displayed? How can we accommodate the array of federal and state agencies, each anxious to tell its own story in its own way? We stretched the ingenuity and creative resources of the institution, but the rewards were high. The result was a unique, award-winning exhibit. Public response was positive, and attendance was good. But more significantly, the aquarium gained new credibility in the eyes of both the public and the scientific community. While speaking to a controversial issue, we promoted communication and strengthened community ties.

Field Museum of Natural History
So Many People, So Many Questions

Problem/Need: "Where do Eskimos get wood?" "How tall are totem poles?" "Would you please send me information about American Indians?" Hundreds of visitors' questions like these prompted Field Museum staff to ask questions of their own. "Where can general visitors learn more about museum exhibits?" "How can such information be presented to a diverse audience that includes all ages, educational levels, and ethnic backgrounds?"

Museums provide a rich variety of learning experience.

The Museum Responds: Field Museum created the Webber Resource Center for Native Cultures of America, a new concept for providing in-depth information to museum visitors. The goal of the resource center is to make accessible to the inquiring public as many of the museum's material and human resources as possible. We recognize that museum visitors bring varied educational and ethnic backgrounds and a diversity of learning styles and needs with them to the museum. A wide selection of resources had to be available: videotapes, audiotapes, books, periodicals, photographs, hands-on artifacts, and study collections. All of these have been assembled in a warm, comfortable room, located in the exhibit area and managed by a friendly, knowledgeable staff. An advisory committee representing area academic, Native American, and Hispanic institutions helped us choose the materials. This collaboration strengthened the museum's relationship with the various communities and assured that the center is sensitive to native concerns.

National Afro-American
Museum and Cultural Center
Exploring the Promise

Problem/Need: The National Afro-American Museum and Cultural Center faced a dual challenge. A new institution under construction, with no track record and limited resources, it needed to build an audience for both the institution and its programs. Inherent in this task was the need to develop widespread support among people in the black community who traditionally were not museum supporters. How does a museum create a sense of comfort and a desire for participation among new audiences?

The Museum Responds: One approach was to develop mutually beneficial collaborations with organizations whose missions were compatible with ours. Collaboration allowed the museum to extend its resources into unfamiliar areas and to address previously unreachable audiences. One project, "Exploring the Promise," included a juried art competition for high school students and senior citizens and an open exhibition for grades one through eight. Also featured was a public lecture and awards presentation by

a significant African-American artist whose personal achievements set standards for all of the audience. This project fostered an alliance among the museum, the school system, senior citizen organizations, and a variety of community and cultural groups. It created an enduring cooperative spirit, a promise to continue the event, and widespread interest in the museum's future.

Lawrence Hall of Science
Youth and Seniors: Science Discovery Workshops

Problem/Need: Educators nationwide have been challenged to prepare students with the critical thinking skills needed in a technological society. Museums are becoming an important resource in this task. The interactive, process-based activities developed at science museums are effective in teaching important problem-solving skills. However, most teachers need guidance in implementing these activities. Hampered by lack of funding, large class size, and little adult help, many have turned to science museums for assistance.

The Museum Responds: "Youth and Seniors: Science Discovery Workshops" was developed in answer to this need. The program is a unique collaboration among the Lawrence Hall of Science, public schools, and senior citizens. Designed to meet the needs of schools that have few science resources, the project recruits and trains senior citizens as the activity teachers. Once they have learned the Lawrence Hall of Science activities and teaching methods, a team of senior volunteers visits schools weekly with museum staff to conduct a series of hands-on biology classes. The culminating activity takes place at the Lawrence Hall of Science. Through this special collaboration, the museum has become an important link in science education. The seniors express a special fulfillment and provide an invaluable inter-generational experience. Perhaps the most enthusiastic participants are the students, who look forward each week to a visit by their special science teacher.

Nancy Evans,
Field Museum of Natural History

Kimi Hosoume,
Lawrence Hall of Science

Juanita Moore,
National Afro-American Museum

Beverly Black Sheppard,
Historic Museums Consortium of
Chester and Delaware Counties

Kathleen Sider,
Seattle Aquarium

Judith Vismara,
Field Museum of Natural History

The Unique Potential of Museums

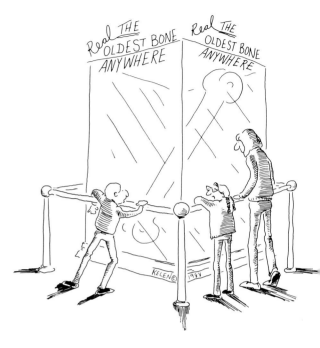

The unique characteristic of museums is that they have real things.

Objects distinguish museums from other learning environments. The most distinctive characteristic of museums has been their stewardship of "the real thing": an authentic Leonardo painting, a 3000-year-old mummy, the actual top hat Lincoln wore. But patterns of contemporary life and thought have challenged our notions about what constitutes a "real" object, how objects communicate, and how they are meaningful. Many science centers and children's museums, for example, provide object-based learning experiences, even though they may not have traditional collections. In all kinds of museums, interactive learning methods have introduced new types of objects, such as models and reproductions, into the galleries. Sometimes educational programs do not refer directly to exhibits and collections at all, but deal with issues and concepts that

stem from the museum's discipline and focus. Even the idea of the museum has been expanded to include institutions with living plant and animal collections. For the most part, however, objects remain at the center of the museum. What has changed are the types of objects that qualify for display and the kinds of opportunities that are available for encountering them.

Try Activity 3, *What Does "Hands-On" Mean?*, to consider the implications of interactive learning.

The learning experience that occurs through objects presents special challenges. Clarifying what these challenges are helps museums play to their particular strengths

and define appropriate exhibit and program goals. A major question is how museums decide what their objects should communicate. Objects do not come with their meanings ready made; people endow objects with meaning. Decisions about how to present objects to the public rest on choices and judgments about the objects' value.

Museums house extraordinary, sometimes rare, but certainly valuable objects. Although public interest in the monetary value of museum objects has been piqued by extensive coverage of record-breaking art sales, the idea of value should not be equated solely with monetary worth. An object's value may derive from a variety of factors, which in turn influence the myriad of meanings the object may hold:

▶ *Exchange.* However it is measured—by the labor expended to produce an object or by its price on the open market—an object's exchange value refers to the amount of something (money, beads, yams) for which it might be comparably exchanged.

▶ *Rarity.* An object may be one of a kind (like most works of art), uncommon (like old matchbook covers), or difficult to obtain (like moon rocks). In a variation on the law of supply and demand, rarity can increase the value of an object.

▶ *Context.* An object's setting can either reinforce or detract from its apparent value; compare an Art Deco water pitcher at a thrift shop to one mounted in an exhibit of decorative arts. Museums pose a particularly authoritative setting for conferring value and, indeed, are often the harbingers of value.

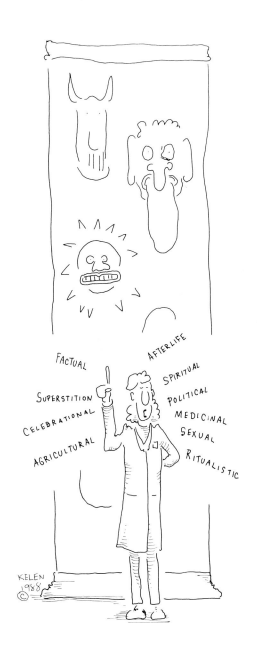

Museum professionals must be fluent interpreters of the many meanings of things.

17

▶ *Accessibility.* The placement of obstacles between an object and a viewer—a sheet of glass, a locked cabinet—can reinforce the sense that what is on the other side must be protected and is therefore special and valuable. Colombia's Gold Museum, to give an extreme example, is located inside a locked vault through which visitors are periodically shuttled.

▶ *Pedigree.* Value may be conferred through lineage. George Washington's wooden teeth, for example, may represent a turning point in the history of dentistry (though they may not), but their value derives in part from the fact that they are Washington's teeth, not Dr. Tootle's.

▶ *Language.* Language can contain hidden values and assumptions. Many museum professionals and academics have stopped using the term *primitive art,* for instance, because it is felt that the word *primitive* implies that the art and its makers are culturally inferior or underdeveloped. The way we talk about an object shapes the way it is perceived and, therefore, what it means.

▶ *Quality.* Qualitative judgments about the skill and care with which an object is created contribute to its value. As the objects of our material culture proliferate, their value has come to be judged according to exceedingly rigorous qualitative criteria. These criteria are among the factors that distinguish the pewter tankard in the gallery from its mass-produced reproduction in the gift shop.

▶ *Taste.* The movement of objects into and out of fashion is a highly unpredictable affair. However it happens, the fact of an object's "discovery" confers recognition, esteem, and, of course, value. Museums help to shape prevailing taste; a recent example is the relationship between the large number of museum exhibitions on American folk art in the last decade and the current public enthusiasm for folk art and crafts.

Value is a judgment, not an inherent property. At different historical moments and under different conditions objects will be viewed according to different criteria of valuation. Every object carries a biography of functions, identities, and values to its resting place in the museum. Over time an object may move through any number of classifications: art, curiosity, antiquity, souvenir, artifact, monument, and so forth. This history frames the way an object is presented to viewers and the meanings they may retrieve from it. An object's significance—to scholars or to visitors—is determined by selective aspects of this past, the choice of which reflect the knowledge, taste, and values of its exhibitors.

To consider the multifaceted meanings an object can have, try Activity 4, *The Meaning of Meaning*.

The learning experience that occurs through objects also presents special opportunities. Objects have a unique educational potential. For one thing, they provide encounters with the real, the authentic. Museums were built around fragments of the real, and this remains one of their strongest draws. In an age when almost anything can be reproduced, facsimiles and copies abound. The development of new ways of producing and manipulating objects has made it harder to say what the actual real thing is. Is there an "original" Barbie doll? an "authentic" Stetson hat? For many—staff and visitors

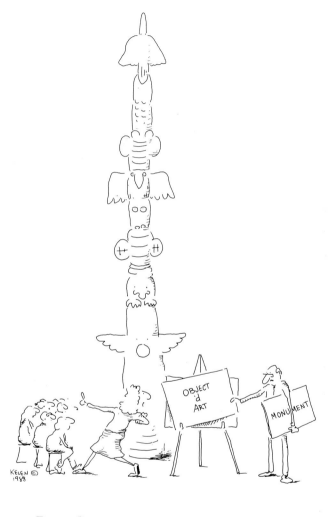

Depending on the context, any object can have a variety of meanings.

19

alike—it is reality and authenticity that endows museums' fragments with that ineffable "something special."

The reality of an object, however, may depend not on some property it contains; it may simply be a matter of how we think about it. When museum curators discover that a painting by a lesser known artist has been incorrectly attributed to Rembrandt, for example, the painting changes irrevocably before our eyes. The painting itself does not change, but the way we think about it does.

Objects also lend themselves to alternative kinds of learning based on what people see and feel as opposed to what they read. In our heavily verbal society, literacy has come to refer primarily to words. But object literacy—the ability to observe and then to compare forms, ask questions, and make critical comparisons—is a skill many people do not have. For museums, this poses a tantalizing challenge: the opportunity to awaken the visitor's underused perceptual capacities, enabling him or her to experience the museum s collections. Museums are no longer merely proud possessors of objects; they are liaisons to objects. They provide active links between an object's and a viewer's traditions.

Museum visits are no longer passive endeavors as museums reach out to visitors with objects.

20

Voices from the Field

Objects: Real or Not Real?

Six people came together at a Kellogg Colloquium to discuss the significance and function of objects in museums. At first we each stressed the importance of real objects in museum exhibits and spoke excitedly about how they "fire the imagination," connect us to other times and places, and transcend the death of a person. But our conversation continually raised new questions. What if we cannot locate the real object or have only a portion of it? What if the object is part of a hands-on exhibit and we fear that touching could impair it? What is truly "real"? How do we distinguish among replicas, reconstructions, and modern-day craft made in the tradition of the old? On which do we place more value? Dioramas and habitats are not truly real; why do we use them? Perhaps, we reasoned, there is a continuum between the real and the non-real, between the original and its representations.

Our personal feelings kept drawing us back to the importance of the "real" or the "original" thing. We asked ourselves why we think it is more meaningful to touch or see a real object. The answer had to do with an emotional connection that we realized would differ in intensity and significance for each person. Real objects have a story to tell. But is there a story in a replica? "Yes," was the response, "with a good educator." We realized this debate could go on endlessly.

We began to focus more on the practical issues. How do we decide to use real objects? How do we decide to use replicas? Which is more important, the experience with the object or the object itself? Finally a premise developed: All objects, real or non-real, have the capacity to "fire the imagination." How this happens depends on the interaction among the object, the visitor, and the museum. Which object we as museum professionals choose to use depends on its availability and on our purpose. Our purpose may be to create a cozy space for contemplation in a corner of the museum or to inspire awe for an ancient tradition, or perhaps we want to teach the structure of a microorganism. Each of these situations dictates the use of different objects; the decision to use original things stems from the purpose. Different kinds of objects have the ability to bring suc-

Real objects have the power to fire the imagination.

21

cessful results because each is also connected, in some way, to the experience of the viewer and the presentation of the museum. For instance, some original artifacts require little interpretation because they hold intrinsic value for many visitors. But if a replica is used, the museum might need to increase its level of interpretation to bring the same meaning to visitors.

It was helpful to see this interaction as a triangle, with three points always present:

▶ the latent power of the object (how it was made or conceived, its monetary value, and so forth);

▶ the context, presentation, and interpretation the museum gives to the object; and

▶ the experience, history, and emotions the visitor brings to the object.

The intensity of each component can vary, but a variety of situations can "fire the imagination," and each is valid on its own terms.

We applied our theory to four situations: the use of the "incredible, original object"; the "patchwork" or partially real object; the model of the object based on the real thing; and the model of the object based upon conjecture. Here is what two of us said about the use and importance of the "incredible, original object."

"Certain objects possess remarkable potential, over and above other classes of objects, to help us in our personal quests for meaning. An artifact from the remote past, for example, has great potential to bridge the gap between an extinct civilization and our own, between maker or user of that object (whose bones are now dust) and ourselves. Such an artifact is a time traveler that has the power to transcend death and fire our imaginations. Through it we attempt to come to grips with what once was and compare that understanding to our current situation. The collection, preservation, and use of such objects by museums is an important quality that sets these institutions apart from others, and it must not be forgotten in our frenzied search for more exciting ways to teach and entertain visitors. What a significant artifact (like an actual dinosaur skull)

can actually 'say' to us depends upon its potential 'power' and upon the knowledge and intention of the interpreters who have selected it, exhibited it, and described or otherwise enhanced it for us. It also depends upon our background, our experience, and the contexts in which we may have observed similar things. A person primed to accept the stimulus that an important, 'powerful' object can impart can gain greatly and lastingly from the experience."

"To the inexperienced eye, one traditional Chinese scroll painting may seem indistinguishable from another. Although the elements of variation seem slight, there is much to be appreciated. There is the form of the scroll itself, the quality and style of brush stroke, the overall effect of the transparency of the ink, the pictorial mountain-water (shan-shu) construction, the evocative spirit of contemplation, and the idea of a person's experience with nature. Of course, this all depends on the context of the painting and the experience of the individual viewer. The museum interpretation gives much to the way the work can be appreciated. The setting may encourage a contemplative spirit rather than a didactic one. A printed text

may offer a philosophical discussion or it may show that in another culture, good fakes were acceptable and used for comparison with masterpieces. The viewer has this personal experience to commit to a personal object vocabulary or memory. This memory contributes to knowing and learning for the future."

A look at the patchwork object shows us that an object composed of real material and reconstructed parts still has the power to fire the imagination:

"We can use a dinosaur as an example of this type of object. Museums are not always fortunate enough to find a complete dinosaur skeleton preserved as a fossil. In fact, a complete skeleton is rare. By using real parts available from many institutions it is possible to reconstruct the animal; often one dinosaur has been constructed from as many as 15 individuals. Trying to reconstruct an extinct animal based on evidence from fossil material and living relatives is a challenge. The anatomy of the closest living relatives of dinosaurs—birds or crocodiles—provides clues that make the dinosaur's reconstruction possible. The patchwork object is the

best educated guess until new information comes along. This type of object may need more interpretation by the museum. The artistic and scientific techniques used to visualize a dinosaur make an exciting story and provide valuable examples of how we make decisions about our world based upon the best available evidence."

Sometimes it is necessary to use a model of the real object:

"Models are often used when the real object would be irreplaceable if it were used and impaired. Although the original object would be preferred because of its innate exhibition appeal, the visitor's preconceived notions, or the object's aura, a replica can have meaning in an exhibit. At the Winterthur Museum, for example, an exact replica of an original tankard made by Paul Revere was fabricated for handling by the adult public. And at the Please Touch Museum, a replica of a hand-carved rocking horse, circa 1850, was created for a historical exhibit on children's play so that children could ride the replica. In both cases, the original object was on display in the same room; out of respect for the integrity of the exhibit, visitors were told that the museum was using a replica. As a result, the museums played a stronger role in presentation and interpretation. The exhibits were effective because they allowed the visitor to experience the weight and feel of the tankard or the fun of

riding the rocking horse, but the originals remained intact. The visitor was better able to add to his experience base and understanding of the past by having tactile experience with the object instead of just seeing it. The visitor also developed a greater respect for the past because the interpreter showed respect for conserving it. Based on its past, the object's latent power was not strong, but based on its present use, the object was very powerful."

The final situation involves a model of an object based on conjecture:

"This object represents an idea based on incomplete or probable evidence and can be used to explain or experience something you cannot see. An example of a model based on conjecture is a feathered dinosaur. Fossil records have not proven the existence of feathered dinosaurs, but evolutionary theory indicates the possibility. This model may raise questions in the viewer's mind and, based on previous knowledge, the viewer can interpret, accept, or deny the theory. Eventually, scientists may prove that the feathered dinosaur on exhibit never existed, but the object will always hold significance as one of the

many theories along the way. Although they are not conclusive, these objects can convey an idea, help us understand a theory, or perhaps open a forum for debate. A model of an idea based on conjecture is as real and powerful as any other object on exhibit, for its interpretation and historical significance aid the viewer and the presenter in better understanding the world around them."

We conclude by admitting that we prefer, if possible, to use the "incredible, original object." But our discussion and our model have made us more tolerant of different kinds of objects and more aware of the power each one holds. We see that all objects have the potential to "fire the imagination"; the extent to which they do so will depend on their relationship with the visitor and on the museum's presentation or interpretation. As interpreters, we now place more value on this "imagination-firing," this experience with the object, than on the object itself. In using objects in our work we will focus more on our purpose and what we intend to communicate, and less on the authenticity or age of the object.

Susan Childs,
Los Angeles Children's Museum

Wanda Chin,
University of Alaska Museum

Dona Horowitz,
Please Touch Museum

Linda Kulik,
California Academy of Science

Arn Slettebak,
Burke Museum

Alexia Trzyna,
Field Museum of Natural History

Summary

Museums have an opportunity to make a significant contribution to public education. Understanding the unique nature of museums involves understanding the distinctive reasons for which they exist as well as the special potentials they hold for enriching the human experience. Clarifying the mission of an individual museum and making a commitment to work toward that mission are the first steps. Added to that must be recognition of the extraordinary power and meaning objects can have when they are encountered in a museum setting. The nature of this encounter is shaped only in part, however, by the special qualities of our institutions. The next chapter looks at the other half of the equation—museum visitors. What do they bring to the encounter with the object? How do they experience the settings we provide?

The same object can evoke different, highly personal visitor responses.

Activity 1

An Organization's Dimensions: Problem Identification Worksheet

Purpose

Every day we face a variety of administrative problems, from the mundane to the serious. Whether we are trying to get a lightbulb changed or mediating a dispute between disgruntled staff members, it is often easy just to deal with problems as they arise and move on. The problems we see, however, may originate elsewhere in an organization's various dimensions: in its value system, goals, structure, climate, or environment. Determining the origin of a problem is the first step toward solving it.

The goals of this activity are:

▶ To understand that the problems we confront and deal with every day may be surface manifestations of an underlying conflict.

▶ To clarify five levels of an organization that affect its personality and operations.

▶ To understand how to pinpoint the levels in an organization at which different kinds of problems arise.

Method

1. This is an individual activity.

2. Complete the Problem Identification Worksheet, a series of statements that describe typical organizational problems. As you complete it, think about a recent working situation you found particularly difficult. Assess the evidence of each problem and code the answer accordingly on a scale of 1 (low evidence) to 5 (high evidence).

3. Analyze the Problem Identification Worksheet. The diagram on this page maps out five dimensions of any organization:

▶ values (the mission and philosophy that form an organization's core);

▶ goals (the means by which an organization's mission is carried out);

▶ structure (the operational aspects of an organization, such as reporting relationships, feedback mechanisms, accountability, decision-making processes);

▶ climate (the nature of an organization's ambience—competitive, cooperative, flexible, or stressful); and

▶ environment (external factors that affect an organization or working group).

Each of the statements on the worksheet refers to one of these five organizational dimensions. Can you identify them?

(Answer: Statements 1 and 2 express conflicts about values, 3 and 4 about goals, 5 through 11 about structure, 12 through 17 about climate, and 18 and 19 about environment.)

Now look at the problem statements that you found in high evidence in your institution. To which dimensions do they refer? How does knowing the origin of the problem help you think about the problem differently?

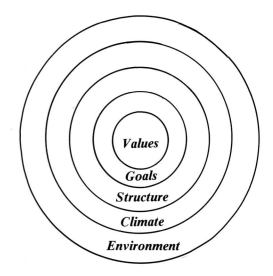

26

Problem Identification Worksheet

1. There is a confusion about the museum's mission.

 1 2 3 4 5

2. There is a difference in values among the staff members.

 1 2 3 4 5

3. The staff members do not clearly understand the museum's goals.

 1 2 3 4 5

4. The staff members demonstrate a lack of commitment to the museum's goals.

 1 2 3 4 5

5. Reporting relationships are unclear.

 1 2 3 4 5

6. There is a lack of accountability among the staff members.

 1 2 3 4 5

7. Decision-making procedures are unclear.

 1 2 3 4 5

8. Communication channels among the staff members are ineffective; people are afraid to speak up.

 1 2 3 4 5

9. There are inadequate mechanisms for peer critique and feedback.

 1 2 3 4 5

10. Staff meetings are ineffective.

 1 2 3 4 5

11. There is a lack of innovation or creative thinking.

 1 2 3 4 5

12. The staff members demonstrate apathy or a general lack of interest or involvement.

 1 2 3 4 5

13. The staff is not encouraged to work together in a better team effort.

 1 2 3 4 5

14. Staff members compete in destructive, hurtful ways.

 1 2 3 4 5

15. Stress inhibits the quality of the staff's work.

 1 2 3 4 5

16. Interpersonal relations are poor.

 1 2 3 4 5

17. Pressures from outside environment significantly affect the quality of the staff's work.

 1 2 3 4 5

18. There is pressure from other parts of the organization for staff members to be more productive.

1 = low evidence 5 = high evidence

Often we to recognize problems on a climate level first. For example, a work group may begin to show a lack of enthusiasm for their work. We tend to identify this climate factor as the problem. In fact, it may be the symptom of a problem that exists on a deeper level. The work group may not have a clear understanding of their mission. The real problem is this lack of understanding; it manifests itself, however, as a lack of enthusiasm. In the situation you chose, can you distinguish the problem from its symptoms?

Adapted from: J. William Pfeiffer and John E. Jones, eds., *The 1981 Annual Handbook for Group Facilitators.* San Diego, CA: University Associates, Inc., 1981. Used with permission.

Activity 2

An Advocacy Role for Museums?

Purpose

Contemporary concerns and societal expectations sometimes collide with the more established practices of museums. This can create a complicated—and often public—dilemma for museum staff. At issue is the relationship between a museum's intrinsic, underlying values and its more current, temporal values. However uncomfortable the process might be, it is useful for staff to clarify and articulate what these two kinds of values mean to them.

Only through the present are we able to interpret the past. Whether we wish to turn our displays and interpretations into lessons of the present is what the question of advocacy is all about. Clarifying this question involves clarifying the relation between the temporal values that inevitably shape how we view the world—including how we view the issue of advocacy—and the deeper, timeless values for which our institutions exist. We must not forget, either, that it is in terms of the former that we interpret the latter.

The goals of this activity are:

▶ To clarify the relationship between intrinsic and temporal institutional values.

▶ To understand the implications of these values for museum practice.

Method

1. This a group activity for small groups of four or five. One group member plays the role of the museum director; the others play museum trustees.

2. Read the hypothetical case of the architecture exhibition at the Mount Forest Museum of Art and History. In small groups, playing assigned roles, decide how the museum should solve the dilemma presented in the scenario.

3. Meet as a large group to discuss the various solutions. Use the questions below as a guide.

Scenario

An Architecture Exhibition at the Mount Forest Museum of Art and History

You are the director of the Mount Forest Museum of Art and History, located in a large metropolitan area. The exhibition committee has approved a proposal to organize a major exhibition on prominent Mount Forest architects of the 19th and 20th centuries in celebration of the city's sesquicentennial. The exhibition will focus on the architects' representative work and will include built and unbuilt projects in Mount Forest, the United States, and abroad.

The organizing curator submits a checklist for the exhibition that includes architectural drawings, models, and photographs chosen on the basis of artistic excellence and technical or stylistic innovation. Some of the material relates to a building designed by the noted architect John Smith that is currently under construction in South Africa. This building is commonly accepted as integral to understanding Smith's work of the past decade.

Anti-apartheid groups in the community learn about the exhibition and protest the inclusion of material on the South African

building. Many staff members agree with this view. The curator and other staff members maintain that this building is essential to the section of the exhibition on Smith's career and that if it is excluded, the quality of the exhibition will be compromised. The architect threatens to pull out of the exhibition entirely if his work is edited. The Director and the museum's board must decide whether to proceed with plans for the exhibition.

Mount Forest Museum of Art and History Mission Statement

The purpose of the Mount Forest Museum of Art and History is to preserve and promote the cultural, historic, artistic, and scientific resources of Mount Forest for both a local and national audience. The museum's primary responsibility is to care for and develop the collection while making it accessible for public enjoyment and education. The museum performs the traditional functions of collecting, exhibiting, and interpreting broad areas of the arts, humanities, and sciences, as well as providing community outreach services that include specialized programs, film loan services, and traveling exhibitions.

Questions for Large-Group Discussion

1. Should museums serve an advocacy role? If so, on what kinds of issues? What obligation do museums have to remain objective and present balanced viewpoints? Should political concerns transcend aesthetic or educational concerns? Under what circumstances?

2. What is the relationship between mission and advocacy? Can we serve an advocacy role if it does not relate to our mission statement?

3. Is a museum's mission statement fixed or can it be revised? Should it be changed to reflect a particular societal issue or pressure? Who can change it?

This activity was created by

Mary Cummings,
Missoula Museum of the Arts;

Susan Curran,
Field Museum of Natural History;

Ellen Dugan,
High Museum of Art;

Audrey Janet Olson,
Roswell Museum and Art Center;

Jean Robertson,
Columbus Museum of Art; and

Carol Bruce Shannon,
City of Colorado Springs Pioneers'
Museum.

Activity 3

What Does "Hands-on" Mean?

Purpose

The terms "hands-on", "interactive", and "object-based" are by now mainstream museum jargon. While all three are used fairly interchangeably, their exact meaning remains somewhat unclear, especially when applied to certain situations. As we strive to address the special opportunities for learning that objects present, we face new questions about what constitutes an object and whether the visitor's experience with the object needs to be hands-on. In addition, we face challenges stemming from the fragility of collections, the availability of objects, and the importance of experiencing the real thing.

The goal of this activity is:

▶ To explore what it means for an exhibit or program to be hands-on, interactive, or object-based.

Method

1. This is a group activity for groups of four to five people.

2. In each group, review one of the following hypothetical scenarios that describes the mission, collections, and exhibits of a particular museum and outlines a task involving an object-based problem.

3. Discuss the questions posed in the scenario, taking care to think about the special problems implicit in the term "object-based".

4. Then join together in a large group to consider the discussion questions listed below.

Scenario 1
Uptown Museum of Science and Industry

You are an evaluation team hired by the Education Department of the Uptown Museum of Science and Industry to review a program still in the planning stage. The proposed program is a day-long workshop for high school students on the basic principles of electricity. During the first part of the workshop, students will be given a short lecture on fundamental terms and concepts. Next they will visit the museum's main exhibit hall to see a large model of a generator. Finally, back in a museum classroom, they will construct their own small generators with the help of a staff instructor.

A stated goal of the Education Department is "to give visitors a hands-on, object-based learning experience in the museum." The department wants the evaluation team to assess whether this program is in keeping with this goal. Your job is to present a report that answers the following questions:

▶ Is the electricity workshop an object-based program? Why or why not?

Work as a team to draft your response.

Uptown Museum of Science and Industry Mission Statement

The purpose of the Uptown Museum of Science and Industry as stated in the bylaws is the "encouragement of public interest in, and understanding of, sciences, primarily through the operation of a museum of science." As the first museum in the United States to bring all the sciences together, this institution serves as a local, regional, and national educational resource. Its goal is to stimulate natural curiosity about all the sciences and to educate the public about the role that science and technology play in our daily lives. At a time when a majority of the population is scientifically illiterate, the Uptown Museum makes an important contribution by attracting a large and diverse audience whose primary exposure to science may be a museum experience.

Collections and Exhibits

The museum's history and its broad-based educational activities are reflected in the diversity of its collections. The collections consist of specimens, artifacts, models, and exhibits dealing with such subjects as aerospace, mammals, insects, minerals, electricity, physics, fossils, and birds.

Scenario 2
Green Museum of Anthropology

The director of the Green Museum of Anthropology recently returned from a splashy international colloquium called "Learning from Things: The Challenge of Education in Museums," which gave her some new ideas about object-based learning. She has sent a forceful memo to the Education Department saying: "There is a need to

reconsider the educational philosophy of our museum to ensure that all our programs are object-based. The only way to increase visitor accessibility to our collections is through hands-on experiences with the objects in them."

As members of the Education Department staff at the Green Museum, you face a problem as you plan this winter's school program. The programs for fifth-graders are intended to highlight a superb but fragile collection of Hopi feather headdresses. All the objects in this collection are displayed behind glass and are much too delicate to handle. Discuss these questions in your group:

▶ Do you agree or disagree with the statements in the director's memo? Give the reasons for your opinion.

▶ Describe one object-based program you would develop focusing on the headdresses that no one is allowed to touch. What kind of object-based learning skills would you be trying to develop in the fifth-grade students who participate in your program?

Green Museum of Anthropology
Mission Statement

In the 1980s, the primary emphasis of the Green Museum is to teach the general public about the native peoples of the greater Southwest—their life, their art, and their material culture. This will be accomplished through exhibition, publication, and other public programming. These activities will utilize anthropological explanations of cultural and racial similarities and differences. When appropriate, the material and nonmaterial cultures of societies outside the Southwest will be used to advance such explanations. Furthermore, whenever possible, the museum will seek local community participation.

Collections and Exhibits

According to the long-range collecting plan of the board of trustees (1977), "The Green Museum should develop outstanding collections of prehistoric, historic, and contemporary Indian arts and crafts." Emphasis is placed on: the "greater Southwest"; decorative, ceremonial, and fine arts of Native American peoples; Mexican folk arts, including ethnographic materials.

Scenario 3
Centerville Historical Society

An active community philanthropist from Centerville, U.S.A., has a long history of supporting the Centerville Historical Society. He has been especially committed to funding programs that serve the black community of Centerville. Lately, he has developed a new interest in the learning styles of young children, and this is influencing his decisions about his contributions. He is especially intrigued by Piaget's concept of learning as an interactive process between children and the objects in their environment. He suggests to the director of the museum that the Education Department develop a series of interactive, object-based programs for Black History Month. He has agreed to provide the funding.

You are Education Department staff members who have been assigned the task of developing such a program. But you have a problem. As a relatively new institution (founded in 1960), the Centerville Historical Society collection lacks certain artifacts of black material culture that would be vital to a full and accurate depiction of black history in the state. Moreover, such artifacts are in high demand among your state's museums and are not available to for purchase or loan.

In spite of these drawbacks, you believe it is important to plan a program for Black

History Month. Consider these questions as you decide how to respond to the donor's suggestion:

▶ Can you develop an interactive, object-based program even though you lack the necessary collections?

▶ If schoolchildren or their parents were to ask why the museum has so few objects of black material culture in its collections, how would you respond? Would you address such an issue explicitly in your program? Why or why not?

Centerville Historical Society
Mission Statement

The museum collects, preserves, researches, exhibits, and interprets objects with the goal of increasing the public's knowledge of the state's history.

Collections and Exhibits

The scope of the collection is artifacts relating to the political, social, economic, and cultural history of the state, from pre-historic times to the present. Chronological and thematic exhibits fill the museum's major exhibition space. Installed in 1968 by the National Park Service, they consist primarily of objects displayed in glass-front cases built into the walls. The subject matter reflects the life of affluent whites, but, in an effort to reach the museum's larger audience, it is occasionally supplemented with photographic panels portraying aspects of black history.

Scenario 4
Delilah Art Museum

As staff members of the Education Department of the Delilah Art Museum, Boston, you are assigned the task of creating a museum orientation program for visiting family groups. The program is to last 15 to 20 minutes and will take place in an empty gallery space near the museum entrance. Each program will accommodate 35 visitors and will be repeated at intervals five times a day. Although you are interested in giving visitors some basic facts about the museum—such as the location of restrooms and cafeteria and news of important exhibits, education programs, and special events—you also want to introduce them to some simple object-based learning skills. Consider these questions:

▶ What are two skills you would like to teach families who visit the museum?

▶ What activities would you plan to help them develop those skills?

Delilah Art Museum
Mission Statement

The primary function of the museum shall be to acquire and display a permanent collection and to present a program of visual arts exhibitions for the entertainment, education, and cultural enrichment of the public.

Collections and Exhibits

The focus of acquisitions for the permanent collection is art created in the 19th and 20th centuries by artists who live or have lived in the New England states, with special emphasis on art by Boston artists. No restrictions are made as to style, medium, or subject matter.

The exhibition of works from the permanent collection changes about once a year. Currently, 19th- and 20th-century art by Massachusetts artists is on view. Each year the museum presents six to eight changing exhibitions of regional, national, and international art of the past and present. About half of these are traveling exhibitions.

Questions for Large-Group Discussion

1. In your hypothetical situation, what factors made your conception of the term "object-based" particularly problematic?

2. How did the nature of the object involved affect the course of your discussions?

3. Can an object-based program or exhibit be developed for any object or topic? If not, why not? Give an example.

Activity 4

The Meaning of Meaning

Purpose

An object in a museum can have a host of meanings, depending on the history of its functions, the context in which we place it, and the associations visitors have with it. As we present objects to our visitors, we are called upon to be fluent interpreters of the many meanings these objects can have. The example in this activity shows how value-laden meaning can be.

The goals of this activity are:

▶ *To understand that meaning can be multifaceted and that different meanings have different implications for the visitor experience*

▶ *To reflect on the conditions of the meaning of an object—not only what it means, but how it means*

Method

1. *This is an activity for five small groups.*

2. *In each group look at the same picture of an object: Bushman the gorilla. Bushman was the most popular and well-known zoo animal in Chicago during the 1940s. When he died he was mounted and displayed at a local museum.*

3. *Give each group a different title for Bushman's display. The five titles are:*

 Manlike Ape

 Gorilla gorilla gorilla

 Cameroon Gorilla: Last of a Dying Breed

 "Bushman": Monument to an Old Friend

 King of Beasts: Strength and Beauty in the Jungle

4. *In each group, outline a label for the object, using the title as a headline. For the purposes of the activity, concentrate on the information to be included in the label, not the actual language.*

5. *Then join together in a large group to discuss the process by which each group arrived at a label outline, using the questions below as a discussion guide.*

Questions for Large-Group Discussion

1. *What is the object? Is it a specimen? a cultural artifact? a political statement?*

2. *In thinking about your label, what assumptions did you make about the object? What assumptions did you make about your audience? How are they manifested in your label?*

3. *Were you aware of assumptions that you might have held about the object? Did you discuss them? How did they influence the contents of your label?*

4. *Without reading your label, how might visitors have looked at this object? What if they came away with the idea that gorillas are mean, dangerous animals? What kinds of implications might such an impression hold?*

5. *What is the goal of making this object "meaningful"? What does it mean in general to make an object "meaningful"?*

The Audience

Describing the Visitor's Experience

The Focus on Audience

Education has always been a cornerstone of museums. For many years, however, traditional wisdom held that education is a passive endeavor: The visitor can have an educational experience merely by standing in front of an object and absorbing its meaning through some magical process of osmosis. But in the past 20 years, educators' theories about how people learn have evolved considerably. Museum educators, too, know more about what constitutes education in a museum setting and how best they can make it happen. As a result, we are developing new language and a body of knowledge that help us portray more accurately the singular qualities of education in museums.

In many museums, audience has emerged as a major focus of our thinking about museum education. Several factors have contributed to the renewed emphasis on audience. As we attempt to serve a growing, more diverse public, we are considering more carefully what our visitors want from our institutions. At the same time, we have become more sensitive to what shapes individual experience, from personal history to the nature of the

We strive to create a learning environment that will promote an "oh wow" experience.

social environment. The growth of electronic forms of communication, the advent of new kinds of family units, and the ever-accelerating pace of modern life are among the conditions that influence people's perceptions and beliefs. Many museums have responded by developing exhibits and programs that better accommodate "where people are."

"Education" might better be described as "visitor experience." The 1984 report, *Museums for a New Century,* introduced a change in the museum vernacular by referring to *learning* rather than *education* or *instruction.* Studies have shown consistently that people do not learn in museums in the same concrete, quantifiable way that they learn in other more structured educational environments. While some museum programs, such as lectures or school tours, do aim to pass on specific information, the typical unstructured museum visit achieves something quite different. A precise description of what is achieved has remained elusive, but it has been variously characterized as a sense of wonder, landmark learning, the flow experience, or the "oh wow" experience. Now the issues of museum education— and the language we use to characterize them—have begun to encompass the more inclusive notion of *visitor experience.*

How will this expanded description of education affect the manner in which we accomplish our work? We must consider the reciprocal relationship between the kinds of goals and objectives we develop and the way we understand and describe our audiences.

Goals and objectives are the staff's fundamental means of making the museum's mission concrete. A goal is a statement in pursuit of the mission, with an end in view. There are two kinds of goals:

▶ *Planning goals* focus on what the institution will do and are written from the institution's point of view: "To develop a photography exhibit for Black History Month."

▶ *Visitor experience goals* focus on the nature of the learning experience and are written from the visitor's point of view: "To develop understanding of the trials and triumphs of the civil rights movement."

An objective, in contrast, is an action statement that is couched in more specific terms than a goal. It describes who will do what by when. There are two kinds of objectives:

▶ *Planning objectives* spell out the institution's role: "By December 1, Bob will conduct a preliminary survey to identify resources in the slide library collection."

▶ *Visitor experience objectives* describe what visitors are intended to do: "As an introduction to the exhibit, visitors will watch a six-minute film that discusses how Martin Luther King, Jr. came to be the leader he was."

Activity 5, *Defining Goals and Objectives*, is an exercise in developing goals and objectives for a hypothetical museum.

Visitor experience goals and objectives are related to creating experiences—curiosity, understanding, awe, or fun, for example. The consequence for staff is a shift in our immediate attention and efforts from the object to the visitor; the object is no longer an end in itself, but a means of eliciting certain experiences in visitors. Being attentive to audience interests and characteristics is therefore a step toward understanding the nature of the visitor experience and deciding how we can best enhance it. The more we

What can we try next to create visitor experience of awe, curiosity, and fun?

incorporate audience concerns into our agenda, the better equipped we will be to formulate goals that both serve visitors and are useful for staff.

The formulation of concrete, written goals and objectives contributes in several ways to the smooth functioning of a project. First of all, goals and objectives are a communication tool. Putting them in writing helps to establish priorities, determine limits, and clarify staff roles. Second, they are a tool for involving staff and helping them feel committed to a project. Enlisting the participation of staff at the outset in determining goals and objectives is a more effective management technique than doling out tasks and information along the way. And, finally, goals and objectives provide a baseline for evaluation. Evaluating the success of a project requires a clear understanding of what we intend the project to accomplish. Clearly

stated goals provide a yardstick for measuring whether a project fulfilled our expectations or fell short of them.

While goals and objectives provide a reference and guide to project operations, they should be modified as new information and new staff perspectives come into play. Incorporating evaluation as a component of project development is essential if goals and objectives of a project are to be tested and revised.

Goals and objectives should be written but never cast in stone.

Voices from the Field

The difference between goals and objectives is more than just semantic. While goals are wide-ranging and perhaps a bit abstract, objectives are concrete and measurable. Objectives help turn lofty ideas into concrete action plans. It may be necessary to develop several objectives to reach one goal. Use the criteria below to evaluate your own goals and objectives.

How Do You Know It's a Goal?

▶ It relates to the overall mission of your institution.

▶ It describes what you hope to achieve.

▶ It is not necessarily realizable, but describes broadly what you are aiming for or working toward.

▶ It begins with "to" followed by a verb.

▶ It is recorded in writing.

▶ It is made concrete through the development of objectives.

How Do You Know It's an Objective?

▶ It specifies a result, not an activity.

▶ It describes just one result you want to accomplish.

▶ It states a time by which the result is to be accomplished.

▶ It emphasizes what will be done, when it will be done, and who will do it, but it does not tell why or how it will be done.

▶ It is feasible in light of projected available resources.

▶ It is clearly related to one or more of the goals.

▶ It is developed and understood by those responsible for its implementation.

▶ It is based on information contributed by those to be affected by it (clients, community leaders, and others).

▶ It details cost parameters where appropriate.

▶ It is specific, measurable, and verifiable.

▶ It is recorded in writing.

Voices from the Field

Museums and Romance:
The Heart of the Subject

Traditional wisdom dictates that one of the major goals of museums is to educate visitors. Yet over the past few years, evaluators and educators have used quantitative methods to show us a plethora of results, almost all of them dismal. Most people appear to learn very little of what they are expected to learn in museums. It is difficult to reconcile the educational/curatorial view of what should happen and the evaluator's view of what actually is happening. We want to teach, but visitors don't seem to learn.

Perhaps people are not coming to the museum to learn. Or perhaps we have an erroneous idea of what learning is. We may have used our evaluation methodology to examine a mode of learning that is inappropriate to our visitors. We might be missing the most important kind of learning that takes place in museums.

In his brilliant little book, *The Aims of Education,* Alfred North Whitehead described learning as a rhythmic process. Through our lifetimes, we go through three stages each time we learn something new: romance, precision, and generalization. Whitehead saw romance as the first and most important of the three, because without it—without an

excitement and a love for the subject—no real learning would ever take place. Romance is hard to measure using quantitative methods, so it is rarely examined.

The learning of details—the stage of precision, which follows romance—is what most of us consider to be real "learning." Yet without romance, detail is dull stuff indeed. Detail, the nuts and bolts of a subject, is the most amenable to quantitative analysis. This is where the educators and evaluators go to town, and this is where those of us involved in the creation of educational exhibits are so often let down.

But the mature learner, Whitehead points out, has a need to place all the detail so lovingly learned into a larger context—the stage of generalization, where we try to place our particular subject into the context of all our learning.

Whitehead's model might well describe learning in museums. Yet what do we most commonly do in our evaluations? We ask questions of precision, of detail; we study our goals and objectives and what the visitor should have learned. Yet people most commonly leave museums with *feelings* of having had either an enjoyable or a distasteful experience. The most powerful museum experiences are the emotional ones, the

romantic ones—the thrill of falling in love with Monet's paintings, the excitement of discovering dinosaurs, the blinding revelations of the spirit. This is the real education that takes place in museums.

Might Whitehead's philosophy guide us? Romance is the hallmark of the museum exhibit. We want people to experience strong emotion—"fall in love"—with our objects, with our ideas. This should be enough. We are neither textbooks nor schools. We should realize that if we use the methodology of schools to assess and improve our effectiveness, we then become more like schools. If we evaluate, we must include methodology appropriate to investigating what Whitehead called romance. If we teach some facts and communicate some more general ideas, if we deal with precision and generalization, it is either because we have allowed visitors to develop a sense of romance toward our objects or because they have come to the museum in a state of romance. We should watch our visitors closely, and if they go away with smiles on their faces and songs in their hearts, that should be enough for us.

Richard Kool,
Royal British Columbia Museum

Voices from the Field

From Romance to Precision

The initial excitement of the visitor's encounter with an object—Whitehead's stage of romance—can become a long-lasting feeling. This happens when the visitor becomes actively involved with the object, making his or her own discoveries rather than simply trying to memorize those of others. At the Columbus Museum of Art, we teach visitors to use a structured line of questioning when they encounter an art object. We suggest that they ask themselves:

1. What element or object in this piece first attracts my attention? Why?

2. How did the artist make this aspect attract my attention?

3. Where is my eye drawn next, and why? (Repeat until a visual inventory is complete.)

4. Now that I've looked at the way the object is organized—those things the artist emphasized through formal means—why did the artist make these decisions? What feeling or point is being presented?

By answering these questions through intensive looking and reasoning, the viewer becomes intimately involved with the object. Whether or not the viewer chooses to go on to the labels, the exhibition catalogues, or the books on the subject, he or she has independently enhanced the romantic experience and can continue to do so in any art museum or gallery setting. These questions can of course be adapted to suit any type of museum.

Sharon Kokot,
Columbus Museum of Art

There are three stages to the learning process: romance, precision, and generalization.

Voices from the Field

Objects are central to the museum experience. No matter what an institution's stated purpose, all museums facilitate encounters between people and objects. Museum professionals seek to prolong and direct the initial response so that it works toward achieving program or exhibit goals. Although the word *meaningful* is difficult to define, our group tried to articulate the meaningful experience with objects by describing it as a layered process.

The process of interaction between object and visitor in a museum setting begins with the object itself. All objects have easily discernible physical properties—such as size, shape, and color—that are not open to interpretation. This information forms the *object core* upon which layers of knowledge and response can be built.

The next layer of information is *scholarship,* the meanings of an object as identified by experts. The evidence of scholarship includes an object's origin or creator,

provenance, age, and exhibit history. These two layers make up the basic information that accompanies every museum object.

The third layer, which is based on the first two, is *presentation*. This is where the museum professional enters the picture. Decisions made during this stage about such factors as design, lighting, or labeling affect visitor/object interaction by shaping what a visitor sees.

The fourth layer—the *initial visitor response*—will be largely determined by the object's presentation, from its interpretive context to its physical setting. The visitor's response is also affected by the "baggage" he or she brings to the encounter with the object. Individual prejudices, taste, and mood will determine a person's

reaction to an exhibit. Although these are variable factors over which the museum professional has no control, they cannot be ignored when thinking about exhibit and program goals.

The visitor's initial response to an object is often emotional: "I love it," "I hate it," "What a nice color," or "Gee, that's ugly." This response may be positive, negative, or neutral. It is the museum professional's job to acknowledge it and use it to advance the visitor to the next step—the *initial cognitive response.* It is important to take the visitor beyond the initial emotional response so that he or she may gain a deeper appreciation of the object. If an object is made interesting or provocative enough, the visitor will willingly prolong the encounter and thus move from the emotional response to the cognitive. The initial level of cognition can be very simple. "Boy, I really like that thing" might be followed by an equally simple but more thoughtful, "My mother used to have one of those" or "That looks like a bird."

The final stage, the outermost layer surrounding the object "core," is the *directed cognitive response.* This is the goal of most exhibits. The museum professional's most difficult task is to entice the visitor beyond the early, "gut-level" reaction into the last, highest level of response. When planning an exhibit, it is often helpful to begin at the outer level of response and move backward to what would probably be the visitor's first, simplest reaction. Is that response going to carry the visitor forward into the upper cognitive levels? Or is it going to allow him or her to walk away from the exhibit without getting beyond the first emotional reaction? It may not be possible—nor will it be appropriate—to achieve the directed cognitive level of response with all exhibits. Sometimes exhibits that convey simple messages are effective in a large topical hall or display. The exhibit must, however, provide the object along with the information the visitor needs in order to appreciate it at the highest possible level. Then it is up to the visitor to encounter the object on an individual level in his or her own time.

How can museums lead visitors to meaningful experiences with objects?

Try the following exercise in charting the encounter between the object and the public.

1. On a large sheet of newsprint draw six concentric circles. This will serve as your diagram of the object/visitor encounter.

2. Choose an object that is on display in your museum.

3. In the center of your diagram list the physical properties of the object (such as size, weight, and shape). This is the *object core* layer of the interaction between objects and visitors.

4. In the next ring list other facts that are known about the object (who owned it, where and when it was made, what it was used for). This information constitutes the *scholarship* level of the diagram.

5. Think about how the object is presented. List the elements of the context in which the object is displayed and the setting in which it is placed. This information is the *presentation* level of the diagram.

6. Record several possible emotional responses to the object, keeping in mind its context and its physical setting. These emotional responses constitute the *initial visitor response* to the object.

7. Next, list some cognitive responses that might follow the emotional responses. Remember to keep it simple; these are average museum visitors, not scientists or art historians. These cognitive responses represent the *initial cognitive response* layer of the object/visitor diagram.

8. Finally, think about the *directed cognitive responses* you hope visitors will have. List these in the outer layer of the diagram.

9. As an additional exercise, return to step 5 and present the object in a completely different setting and context. Then proceed through the next steps, keeping in mind that the responses are based in part on the object and in part on the presentation.

Look over your diagram and think about what kinds of things you can do to help visitors move from one layer of a meaningful encounter with objects to another. Try going backward through the steps, beginning with the desired response at the cognitive level and working down to the presentation level. The results of this exercise may affect future decisions on how the object is presented when you want to elicit a particular response.

Jean DeMouthe,
California Academy of Sciences

Phil Hanson,
Field Museum of Natural History

Vicky Middleswarth,
Kentucky Historical Society

Kelly Nolte,
Jamestown Festival Park

Peggy Tolbert,
Snite Museum of Art

Robert G. Wolk,
North Carolina State Museum
of Natural Sciences

Describing our Audience

A visit to a museum is a highly individual experience. Talk to three eight-year-old girls about their walk down the "Street of Yesteryear"; each will undoubtedly give a different story. Even though they each may belong to categories—such as "six- to eight-year-olds" or "motivated learners"—what matters to the individual child is that she is a member of the Smith family and has two big brothers, a hamster named Buster, and the best collection of bottle caps in the third grade.

Enabling the visitor to reach a personal level of experience is a museum's ultimate goal, but it is the goal that we are least able to control because it depends on the facts and idiosyncrasies of people's lives. We need to be sensitive not only to the role of our institutions in presenting and interpreting objects, but to the role of our visitors, who make their own personally meaningful interpretations.

To explore how staff attitudes affect visitor experience try Activity 6, *Working Toward Positive Change.*

By providing a variety of opportunities for visitor experience, museums can serve a wide spectrum of audiences. Perhaps the most indisputable generalization about museum visitors has become the most trite: A variety of people come to museums for an enormous variety of reasons. The simple fact is that an untold number of visitors walk through the door because they have some time to kill before the movie, it started raining outside, the museum is part of a whistle-stop tour of city highlights, or dinosaurs and mummies happen to be "in" this year. Since visitors have such diverse motives and expectations, many museums try to provide opportunities for a variety of kinds of experience. We hope that each visitor, given an adequate range of opportunities, will find a "hook."

How we describe our audiences influences how we define our goals. If we want to develop exhibits and programs that appeal to our audiences, we need to clarify both the nature of the appeal and the ways our exhibits and programs can satisfy it. To take full advantage of the opportunities museums offer for experiencing and learning, we must be clear about to whom we are offering them. By describing audiences in different ways, we can acquire different types of information, which we can then apply to realizing

Describing desired visitor experience is important to setting goals.

particular kinds of goals. Three types of audience description can be useful to museums:

▶ *Demographic* descriptions include data about population size, age, geographic distribution, occupation, income, and so forth. Demographic information gives us a broad picture of our potential audience, so it can help us set realistic goals for attracting and serving visitors or members. Knowing that a community's senior citizen population is growing, for example, might affect our goals for volunteer recruitment, program and exhibit development, or marketing.

▶ *Typological* descriptions classify visitors according to particular characteristics. Groupings are usually based on criteria such

as developmental characteristics (the experiences, circumstances, and concerns that mark different stages of the life cycle); learning style (interactive, self-directed, or teacher-directed); visitor motivation (education, social interaction, cultural enrichment, or emotional stimulation); or psychographic characteristics (values, attitudes, interests, and expectations). Typological descriptions help us set goals and limits for an exhibit or program by clarifying the types of people we aim to attract and appealing to their interests and needs. We might accommodate several learning styles in the same exhibit, for example, by providing labels, an audio tour, and interactive activities.

▶ *Behavioral* descriptions relate to what people do during their visit to a museum: what path they follow through the exhibit halls, where they stop, how much time they

spend with displays, whether they discuss what they see, what use they make of interpretive materials. No less important to the total ethology is the length of their stay, whether they stopped to eat, how many times they used the bathroom, whether they visited the gift shop, what they bought, and how much they spent. However laudable a museum's goals for its visitors, the museum visit is ultimately a function of pragmatic as well as qualitative concerns. Behavioral descriptions help us set goals and make decisions about such practical matters as the physical layout or the attracting or holding power of objects on exhibit.

To test assumptions we make about audience, try Activity 7, *Thinking about Audience.*

Defining visitor experience goals and objectives requires a type of audience description that is based on a broad understanding of the visitor's experience. Typically, our descriptions of audience are based on demographic information, which is readily available. When we formulate goals and objectives in terms of what we hope visitors will experience, however, we need to draw on demographic, typological, and behavioral descriptions. Together, they all give us information about different aspects of visitor experience, but by focusing on the *experience* we are not locked into the kinds of assumptions we often make when using any of these types of

descriptions on its own. For example, we often set goals based on the developmental stage of our visitors. We assume that children have a proclivity for more active experiences that help them ascertain and assert a sense of control over their world, and that adults are more interested in self-directed, contemplative experiences, since they have well-developed capacities for abstract thought and historical understanding. We have observed, however, that adults may enjoy concrete interactive learning experiences as much as children do. Every visitor has a different potential, style, and capacity for experiencing and learning. Audience descriptions that take this into account can help us formulate goals and objectives that are directed to visitors' experience, regardless of who they are.

Voices from the Field

Visitor Experience and Exhibit Context

In museums artifacts exist in a variety of contexts, both by accident and design. Making contexts that are purposeful—that is, imbued with meaning—is one of our principal challenges. And what a challenge it is! It requires negotiating a rough terrain filled with questions—some beguilingly simple, others ferociously complex. Nonetheless, our group has struggled across this terrain in an attempt to devise a method by which museum staffs could assess the contexts their exhibits give to artifacts and the experiences their exhibits give to visitors.

In many ways, these contexts and experiences of exhibits come to represent the museum itself. A museum becomes known for particular kinds of exhibits and particular kinds of activities for its audience. Many museums are investing enormous amounts of time, money, and effort in changing the contexts of their exhibits. They have been spurred by many concerns: Greater awareness of the unmet needs of existing audiences, a desire to serve new audiences, advances in design, recent discoveries in how people learn in museums, and heightened worries about

the fragility of collections are only a few. Exciting new exhibits have been created, but a byproduct has been concern for what these changes mean for an institution's identity. Are important goals being sacrificed? Should we be concerned about a loss of meaningful context when a museum changes either its approach to exhibit design or content? Exactly how does a museum reconcile change in exhibit context with the expectations of its staff and public?

One way to answer these questions is to describe the ways in which exhibits' contexts are meaningful to visitors. A systematic means of description allows us to compare the different ways context is created and discern the styles that emerge. While the context a single exhibit creates may not tell us much, a museum visit consists of the sum of many exhibits. Consistent criteria for assessing individual exhibits may help create an index describing the context a museum as a whole creates. In effect, this becomes a way of

identifying the personality of the museum. As exhibits change, this index will change. What may have appeared at first glance to represent enormous change in exhibit context may turn out to be a more modest broadening of approach when put into this larger perspective.

A systematic assessment can also be useful in both planning and evaluating new exhibits. For example, an exhibit planning team may discuss at the outset of a project what kinds of context they want to create for an object and what kinds of impacts that context might have on visitors. They may decide that since their museum has many lively participatory exhibits, they need to broaden the museum's personality by creating an exhibit with a more serene environment. Visitor behavior in the finished exhibit can be compared to the initial goal as one measure of the exhibit's success.

The index we have developed inventories exhibits in three areas: what visitors are asked to do, learn, and feel. In addition, a summary category asks how satisfying the experience was. All exhibits elicit these four responses—doing, learning, feeling,

and satisfaction—to some degree. It is the mix of the first three that determines the fourth and creates the particular style of the exhibit. These categories correspond to what we believe are principal responses of visitors in exhibits.

Doing: This category asks about sensory experiences and activities. What do visitors hear, see, touch, and manipulate? Can they jump, wander, try something on? Obviously, different types of exhibits ask for different types of responses. Baby zoo animals tempt children to rush over and pet them. In contrast, a Japanese painting with a comfortable bench before it invites the visitor to sit and contemplate the painting's serene and subtle beauty. These are but two examples at the extremes of an enormous continuum. In all exhibits visitors are asked in varying degrees to *do* something, whether it is to read labels, interact with objects, touch things, watch videotapes, listen to music or voices explaining aspects of the exhibit, smell aromas, taste foods, or even think about an idea, comparison, judgment, or concept the exhibit suggests. The key question is: What are visitors encouraged to do in the exhibit, and how important to their total experience is it?

Learning: This category asks about information the exhibit conveys. What do visitors learn? Is it facts, concepts, or skills? Do visitors classify information, make comparisons and contrasts, or evaluate hypotheses? Some exhibits set out to teach new information, concepts, or skills to visitors. Others are concerned with conveying general ideas or piquing interest. Regardless of the level of complexity, the key question is: What are visitors encouraged to learn, and how important to the experience is it?

Feeling: This category asks about what the exhibit makes visitors feel. Are they awestruck, energetic, mystified, repelled, bored, or indifferent? Some exhibits use lighting to convey a mood, others simply to illuminate the artifacts. Some use historically accurate colors to convey part of the interpretation, others use them to evoke an emotional response. The arrangement of the physical space may convey feelings of expansiveness or of privacy or secrecy. Here the key question is: What feelings and emotions was the exhibit designed to foster in visitors, and how important to the experience are they?

An exhibit can elicit visitor responses of doing, learning, feeling, and satisfaction.

Satisfaction: This category encompasses the other three. Exhibits should provide a gestalt in which the doing, learning, and feeling make sense. This category asks how well the exhibit does this. Does the exhibit give visitors a sense of control? Does it give them a sense of discovery or help them find personal significance in the experience? Are they so absorbed that they value the experience and want to repeat it? Is there a sense of enrichment? The key question is: After visitors have done something, learned something, and felt something, what did it add up to? Was it a satisfying experience?

An exhibit can be assessed by weighing the proportions of doing, learning and feeling opportunities it provides, and by considering how well these opportunities work together to create a satisfying experience for the visitor. This assessment may not be quantifiable. It is better to think of it as a self-study and a springboard for conversation. Exhibit developers may, for example, visit four exhibits in their museum and answer the following questions about them: What was the visitor asked to do, feel, and learn? How were each of these aspects of the experience weighted? To determine how well exhibit context creates a satisfying experience, they may answer these questions: How well did these three components of experience resonate together? Is the balance right given the subject matter, intended audience, and museum mission?

If these categories were used as a visitor evaluation rather than a self-study tool, museum staff would need to study what visitors actually do, feel, and learn in the exhibit. For clues in the satisfaction category, ask such questions as: Are they focused and absorbed? Do they share personal comments and observations about the objects? Do they return to the exhibit?

Individual exhibits in one institution may well show a wide variety of styles, but the composite picture may represent the institution's exhibition style. Some elements may be consistently slighted, and thus selected for greater emphasis in future projects.

These four categories can help staff think about the messages that are implicit in our exhibitions and the identity or personality our museum projects. They can serve as a self-study device to examine the emphasis of each exhibition as an aid in developing a balanced, but varied, exhibition program. They can also be used in developing a homogeneous exhibition program whose emphasis accurately reflects the museum's expressed mission.

However our categories are used, the goals remain the same. To do our jobs well, we must create exhibits with meaningful contexts for the objects and visitor's interaction with them. Only by giving careful and consistent thought to this challenge can we hope to create satisfying experiences for visitors.

Marlene Chambers,
Denver Art Museum

Michael McColly,
Field Museum of Natural History

Steven L. Olsen,
Museum of Church History and Art

John Terrell,
Field Museum of Natural History

Thomas C. Thompson,
Minnesota Historical Society

Robert M. Woltman,
Albuquerque Museum

Summary

New ways of thinking about the special nature of education in museums have led to new ways of thinking about the audiences we serve. We are shifting from traditional views of museum education as didactic instruction or passive encounter to a view that encompasses a broad range of experiences. This shift has two major implications for museum staff. First, it means that we must formulate goals and objectives that encompass a wide gamut of experience and give the experience equal weight with the object. And, second, it means that we must cultivate an expanded understanding of our audience that involves not just who they are, but what they expect, what they think, and what their base of experience is. The next chapter looks more closely at these implications for staff.

The diversity of our audience presents us with a challenge.

Activity 5

Defining Goals and Objectives

Purpose

We all know that defining goals and objectives is an important part of the program development process. But what seems simple and straightforward in theory can sometimes be a challenge in practice. When we think about institutional planning goals and objectives we consider the mission and resources of our institution. When we define visitor experience goals and objectives we think about the interests and abilities of our visitors. If our planning process is to result in attainable goals that are in tune with visitor expectations, we must consider both sides of the museum/visitor equation.

The goals of this activity are:

▶ *To practice writing goals and objectives in a hypothetical, no-risk situation.*

▶ *To learn how to distinguish between institutional planning goals and objectives and visitor experience goals and objectives.*

Method

1. *This is a group activity for teams of four. Members should represent the perspectives of an educator, a curator, an exhibit designer, and a project manager.*

2. *Using the hypothetical case of the American Consumer's Museum, work in groups to draft a theme for an exhibit and related goals and objectives. Each team should write at least two planning and two visitor experience goals and objectives.*

3. *Reconvene in a large group and discuss the results of each team's work, using the discussion questions below as a guide.*

Scenario
American Consumer's Museum

Your team has just been hired as exhibit development consultants for the American Consumer's Museum, a small museum located in your hometown. The museum exists to preserve, increase, and disseminate knowledge of and delight in American consumer attitudes. The museum's areas of interest include the evolution, composition, and use of consumer goods, past and present. To achieve its purpose, the museum acquires and preserves collections in its area of interest, promotes and publishes original research by its staff, and actively educates through exhibits, lectures, and other methods. The museum's collection consists of 300 objects dating from 1902 through 1981. All objects in the collection have at times been sold through mail-order catalogues. Included are clothing, household wares, furniture, toys, and tools.

The director has asked your team to develop a new exhibit using part of the permanent collection. Although she has no preference as to the theme you select or the portion of the collection you use, she is interested in expanding the audience the museum now serves. She asks you to develop an exhibit specifically geared to senior citizens, because the museum has not been successful in attracting this segment of the community to its exhibits and programs.

Your first assignment is to develop a proposal that the director can use when she approaches a local mail-order firm for a special grant to fund the exhibit. The proposal should include a statement of the exhibit theme, institutional planning goals and objectives for the exhibit, and visitor experience goals and objectives for the exhibit.

This is your team's first meeting to work on the proposal. The meeting is to last one hour. Although you may not finish the proposal, you should try to formulate a theme, two institutional planning goals and objectives, and two visitor experience goals and objectives for the exhibit.

1. *How do your visitor experience goals reflect the audience that you want to attract? What kind of assumptions did each perspective (curatorial, educational, design, managerial) make about audience?*

2. *Is the mission of your institution reflected in the goals and objectives you wrote?*

3. *Have each team write their goals and objectives on a blackboard or flipchart. Using page 43 as a guide, critique your lists by discussing whether each item is indeed a planning or a visitor experience goal or objective.*

Activity 6

Purpose

The nature of every museum visitor's experience is a function of both personal orientation and the museum's manner of presentation. Yet the way a museum presents itself entails more than the layout of the exhibits, the location of the restrooms, and the architecture of the building. Any visitor's experience can be enhanced—or diminished—by the attitudes museum staff communicate through their behavior. We may not be able to make our buildings look less imposing, but we can control our own role in making the visitor's encounter a meaningful one.

The goals of this activity are:

▶ To examine staff attitudes and behaviors that have an impact on visitor experiences.

▶ To examine how the museum environment affects visitor experiences.

Method

1. This is a small-group activity. The participants can be an interdisciplinary team, an exhibit team, or department staff.

2. As a group, read the hypothetical scenario for the Marlebone Museum of Art.

3. Then discuss the following questions:

 ▶ What were the environmental factors at play during the students' visit?

 ▶ What impact did the staff's behavior have?

 ▶ What institutional attitudes did that behavior demonstrate?

 ▶ What was visitors' perception of the institution during and after the visit?

 ▶ How could the visit have been better handled?

 ▶ What changes might be made to better meet the needs of the audience?

4. Meet to share your responses with the large group.

Scenario
Marlebone Museum of Art (MMA)

It is 9:40 on a chilly October morning in Marlebone, a midwestern community with a population of 80,000. A bus with two fifth-grade classes from Lincoln School arrives at the MMA parking lot, ready for "A Morning at the Museum." The children crowd off the bus under the loose control of Ruth Stompster and Billie Laidlow, the two teachers accompanying them. Stompster leads the group through the museum entrance closest to the parking lot.

There is considerable activity within the large, open lobby area: The receptionist is talking on the phone, a custodian is on a ladder changing lightbulbs, a woman is using a noisy, high-volume copying machine, two people appear engaged in a heated conversation. The teachers and 48 giggling children attract little attention. Stompster asks the staff member at the copying machine where to find the tour guides. The woman glances idly at the fifth-graders and replies: "Oh, school tours go to the front entrance. They'll be waiting for you there." After receiving directions, Stompster, Laidlow and the children leave the building and circle it to the front entrance.

As the tour group approaches the front entrance, several of the children spot a sculpture courtyard next to the building and race into it. Laidlow goes after them, while Stompster tries to open the doors. They are locked, and the lobby appears deserted. Stompster pounds on a door, and a figure emerges from a stairway leading to the lobby. It is Fran Love, an MMA docent. She opens the door a few inches and tells Stompster that the tour isn't scheduled until 10:00 and the doors will be unlocked at that time. "Please keep the children close to the door until then." Love closes the door and disappears back down the stairway.

Because the children are already complaining about the cold, Stompster and Laidlow walk them around the building again to take up some of the eight minutes they must wait. At 10:00 sharp a guard unlocks the front entrance. The children push through the doors into the lobby, with Stompster in front and Laidlow behind. The guard has gone into the gallery area; there is no receptionist and no sign of the docents. Stompster confers with Laidlow, while the fifth-graders mill around the lobby looking at various paintings and sculptures on display. A group of boys gather around an attenuated bronze nude, speculating loudly on various causes for the figure's extreme thinness. Other children wander into an adjoining gallery.

Just as Stompster decides to go downstairs for help, Fran Love and another docent come out of the gallery, leading the group of wandering children. "We are ready for you in the auditorium. Please have the children follow me down the stairs and we will begin the orientation." Fran heads downstairs while the teachers and a second docent, Mary Weary, corral the children and direct them to follow. As they pass downstairs, the children noisily ask about where they are going, what they are going to do, and when they are going to see art.

The children are seated and asked to remove their coats. Fran Love introduces herself and Mary Weary. The orientation is devoted entirely to an explanation of the mechanics of the morning's activities. Love explains that because a third docent has failed to arrive, the behind-the-scenes tour has been cancelled and the children will be divided into two groups instead of the usual three. Each group will be led by

a docent and accompanied by a teacher. Fran Love's group and Stompster will tour the exhibits, while Mary's group and Laidlow will go to the school wing for the studio art project.

There are four galleries in the museum wing. Current exhibits include a show of recent work by area artists in a variety of media and a selection from the MMA permanent collection. The first stop for Fran Love's group is the area show. Love announces that she wants the group to think about the different materials that artists use to make art. She gives each child a pencil and a list of materials that can be found in the exhibit and instructs them to find each of the materials listed. The exercise turns into a contest, with children scurrying from one object to the next, each trying to complete the list before the others. A number of terms are new to the children and both Stompster and Love keep busy explaining words like

"alabaster" and "earthenware." The gallery search is followed by a review of the terms, with the children pointing out where they found their examples in the exhibit.

Because so much time was spent with the area show, there is no time to talk about the permanent collection exhibit. Love takes the group on a quick walk through the gallery, pointing out that the MMA owns all of the works. It is then time to go to the school wing for the art project.

Love's group arrives in the school corridor just as the Mary Weary group is leaving their classroom. Children from the two groups mingle for a few minutes and exchange comments on their experiences. One girl from Weary's group, on hearing that the exhibit tour "wasn't so hot," decides to stay with a friend in the Love

group and do the art project again. The switch goes unnoticed by both docents and teachers.

In the classroom, Ann Marie, the art teacher, is still cleaning tables from the previous group. She cheerfully asks the students to sit at the tables while she finishes the cleanup and distributes materials. The extra girl in the group is finally noticed when they are one stool short at the tables. Stompster takes the girl away to find and rejoin the Weary group.

The art project for the day is an exercise in collage. The children are given a variety of colorful paper and cloth scraps and other materials, along with scissors and glue. They are asked to re-create something they have seen in the museum that morning. Some students begin working immediately; others require considerable prompting from Ann Marie before they settle on a subject; a few become upset at their failure to think of a good idea and

are calmed only when Ann Marie suggests they make Halloween pumpkins. The classroom session ends with the individual projects in various stages of completion, but the children are allowed to take what they have made as a souvenir of their visit to MMA.

By noon both school groups are back together in the auditorium, their morning at the museum behind them. While the children struggle into their coats, Fran and Mary give evaluation forms to the teachers to fill out. As Fran says, "These evaluations are important to us. We want to do what we can to make 'A Morning at the Museum' a good experience for all of you."

This activity was created by

Terry Boykie,
New York Hall of Science;

Marie Hewett,
Strong Museum;

Joyce Matuzewich,
Field Museum of Natural History;

Janet Pawlukiewicz,
National Museum of Natural History;

Helen Sheridan,
Kalamazoo Institute of Arts; and

Ralph A. Wilke,
St. Louis Science Center.

Activity 7

Purpose

In recent years museum professionals have been paying more and more attention to understanding their audiences. We are wrestling with what that understanding should consist of and how it relates to exhibit and program development. Descriptions of our visitors that are based on their abilities, learning styles, or motivations—as opposed to descriptions of who they are—relate more effectively to the experience visitors have in our museums.

The goals of this activity are:

▶ *To think about the kinds of assumptions we make about visitors.*

▶ *To explore how those assumptions influence program and exhibit goals.*

Method

1. *This can be either an individual activity or a group activity for a team from one museum.*

2. *This is a two-part activity. During part 1 (40 minutes), read "The Kidnapping Scenario" and answer the questions presented in it. Don't look ahead to "The Missing Information" presented in the Part 2 scenario.*

3. *During part 2 (20 minutes), read "The Missing Information" and answer the questions presented.*

4. *Reconvene in a large group for discussion, using the following questions as a guide.*

The Kidnapping

You are blindfolded, put on a plane, and taken to an unidentified museum. After you arrive, your blindfolds are removed and you find yourself in a large, window-less exhibit and program planning office. You are told to develop an educationally effective, popular exhibit and related educational programs on contemporary American clothing. You have one week to deliver exhibit and program goals, a basic exhibit script outline, and a list of artifacts you want to include in the exhibit. Your kidnappers refuse to tell you what kind of museum you are in or where it is located.

What assumptions do you make about your audience? What do you plan to include in the exhibit and programs? List two exhibit goals and two program goals.

The Missing Information

Surprise! Your kidnappers were sent by your team's own director. You have been in the basement of your own museum. Think about your museum's mission, collections, and audience. Revise your exhibit plan based on this new information.

Consider these questions:

▶ Does this information cause you to change your assumptions about visitors? Why or why not?

▶ How does the information about the museum's audience lead you to change the goals of your exhibits and programs?

▶ How does the information about the museum's mission and collections lead you to change the goals of your exhibits and programs?

Questions for Large-Group Discussion

1. *What assumptions did you make about your audience? How did these assumptions influence exhibit goals? program goals?*

2. *Did your assumptions change when you found out the "missing information"? How? What does this tell you about the kinds of information museums should try to obtain about their audience?*

The Staff

*Putting Museums and
Visitors Together*

Voices from the Field

The Frame and the Framers

In Paris at the Musée d'Histoire Naturelle stands a tower of stuffed animals and skeletons. Up and up it goes, nearly to the great glass roof overhead. Antelopes on the left of it, zebras on the right, its apex is a crowd of six giraffes. Of all the exhibitions emblematic of the Victorian Age, perhaps it is the most fitting. What are its meanings? There are, to be sure, taxonomic lessons in the species piled together. There may be a message about the diversity of life, or at least of mammals. But I think the truer, deeper meaning is in the presentation. How Victorian it is to amass such abundance, how typical to display such wealth, such hunting prowess, such mastery over the animal kingdom. And the greatest achievement of all is the creation of an engineering marvel—a pyramid of animals disappearing into the sunlight above.

The tower and other exhibitions from the last half of the 19th century reveal the cultural assumptions of their creators quite adeptly. Underneath them all lie some consistent themes:

▶ The world can be organized and understood.

▶ The world is abundant and there for the taking.

▶ There is a hierarchy rising from the simplest, one-celled organisms to white male humans.

▶ Progress is both the grand engine and the story of life.

So might a cultural historian read the evidence of the exhibition, mining it for clues about the thoughts, hopes, and world view of the exhibit's creators. These are meanings that dwell in no object or specimen. They are embedded in the structure of the exhibition itself.

But our own exhibitions can be similarly read. We carefully control the experience, and we choose each artifact to carry an interpretive point. Exhibits lovingly protect the artifacts. Many points of view and voices speak out. Classes, tours, programs, and performances provide a variety of opportunities for the visitor to be involved. What are we saying? Perhaps that:

▶ Life is complex and mysterious. We need the help of experts to understand the world and ourselves.

▶ The world is dangerous, but we can capture and know it.

▶ There are many perspectives, and our place in the world is relative.

▶ The world is vast. We should always keep learning.

Great attention has been focused on exhibition techniques in the past two decades. Concerns about the fragility of collections,

research about how people learn, redefinition of museums' educational responsibilities, and new exhibition technologies have all played a part in enlarging the interpretive techniques of exhibitions and their satellite programs. With these changes have come great opportunities.

In the midst of these exciting times, let's think back to the tower of mammals in Paris. As important as the intended meanings of our artifacts and exhibit interpretation techniques are, it is essential that we understand the deeper meanings with which we imbue every object. Our exhibits are like great pictures, and we expect visitors to study them, not the surrounding frame. But the frame—and we the framers—are a matter of great interest. Let's study ourselves

and our work from this broader perspective so that the meanings we intend do not get hidden behind those that we don't.

Thomas C. Thompson,
Minnesota Historical Society

Voices from the Field

Communicating Values, Communicating Reality

The peculiar environment of a museum exhibit creates unique opportunities for educating visitors in the human and symbolic, not simply the empirical and technological, qualities of our lives. Museums educate their visitors in informal, social, and artifactually rich settings, using visual, tactile, kinesthetic, and verbal means of communication. Thus exhibits are more like the real, value-laden world than are classrooms or other, more abstract learning environments. Exhibits distill and focus reality through a particular perspective or interpretive framework, presenting an essence of that reality in terms meaningful to the visitor.

If this is true, exhibits fall far short of their potential if they do not communicate their motivating assumptions and do not educate their visitors about the attitudes and values that make them meaningful. Museum exhibits bear the responsibility to help visitors understand the "why" of their subject matter, not only the "what," "where," "when," and "who."

Exhibits in art and history museums have traditionally left implicit the interpretation of values. In this regard, curators, following the lead of their scholarly cousins in the academic disciplines, have produced well-researched exhibits that may be lacking in interest for a lay audience. A vocal minority, also following the lead of their scholarly but more activist cousins, have addressed contemporary, often controversial issues in exhibits, thereby attempting to teach relevant social values. These exhibits have tended to address a narrow range of concerns within the broad spectrum of human, social, and environmental issues that make life meaningful. Smaller still is a group of scholars who have identified in the deep structure of museum exhibits the values and assumptions that motivated and guided their development. While insightful, this discovery may not help the uninitiated visitor, except perhaps at a subliminal or pre-verbal level, to understand the full significance of those exhibits.

The proposal that the communication of values be an integral and conscious part of museum exhibitions does not contradict these traditions. It suggests that "reality" is as much a human and symbolic as a scientific and empirical phenomenon. Thus our understanding of reality, whether obtained directly through experience or indirectly through communication (as in an exhibit), is necessarily influenced by human and cultural values. It also acknowledges that values are generally communicated among ordinary members of society, in everyday settings, using common objects and materials.

Each characteristic of the reality in which values are communicated is particularly suited to the environment of museum exhibitions. As a result, exhibitions may be better suited to the communication of values than to the transfer of facts, which is the specialty of the textbook. The more directly that relevant values are interpreted in museum exhibits the more likely that those exhibits will reflect a reality museum visitors understand and appreciate.

Steven L. Olsen,
Museum of Church History and Art

Voices from the Field

Articulating Your Ideas about Museum Education

Putting your thoughts—however sketchy they may be—into words is a good way to increase your awareness of your own motivations and priorities. Juxtaposing your own philosophy with the mission and philosophy of your institution will also help you see the extent to which the two coincide. Take a few minutes to think about where you stand in regard to education as it fits in to your museum. Use this simple framework to begin arranging your thoughts.

1. I think that the ultimate point of education in my museum is:

2. I think that the main contribution I can make to achieving that goal is:

3. From my work with museum visitors and from my own life experience, I find these things to be true about people:

4. From my work with museum visitors, I believe that most of the education that museums make possible happens when:

5. The program (or activity, or exhibit, or workshop) I have developed that exemplifies my own philosophy of education in museums is:

 I consider it the best reflection of my philosophy because:

6. The program (or activity, or exhibit, or workshop) I have experienced that exemplifies my own philosophy of education in museums is:

It is important to understand whether or not our personal and institutional philosophies coincide or collide.

Goal-setting and Role Clarification

Institutional planning goals and objectives are one way we interpret the mission of our institutions. Many variables—from the size of the budget to the personal philosophies of museum staff—influence these interpretations. Unlike visitor experience goals, which focus on what we would like people who visit our museums to experience, planning goals and objectives focus on what the museum staff will do to help make that experience happen. Compare these goals and objectives:

▶ *Visitor experience goal:* To increase appreciation for Picasso and his influence on the history of art.

▶ *Planning goal:* To determine the audience's knowledge of and interest in Picasso.

▶ *Visitor experience objective:* Parents and children will participate in a live theater performance entitled "Picasso in His Studio" with a trained interpreter.

▶ *Planning objective:* By October 1, Bill will prepare a survey instrument for a study to learn about visitors' previous exposure to Picasso and their special areas of interest in the artist.

Like visitor experience goals, planning goals provide a good opportunity to include a wide range of staff members in the planning process. Planning goals can help us communicate with those who will be affected by our plans, even though they may not be responsible for developing them. Like visitor experience goals, they are one standard by which we evaluate the effectiveness of program planning and implementation.

Many factors are involved in considering how to bring museums and visitors together.

75

A variety of staff perspectives are needed in the development of goals and objectives. As we pay more attention to the interests and abilities of museum visitors and as new definitions of desired visitor experience emerge, new forms of specialization are developing in museums. The most obvious has been the emergence of staff who can be considered "audience specialists"—usually, though not always, called educators. Other roles are changing, too. Designers are breaking away from old traditions to incorporate new technology in their exhibits, and they are becoming media and materials specialists in the process. Curators have always been subject matter specialists, but now they work not only to stay abreast of the latest scholarship, but to present the information to the public in an accurate and timely way.

While specialization can breed isolation, it holds the potential for stimulating healthy cross-fertilization of personal and institutional perspectives and aims. Teamwork is what enables this cross-fertilization to occur. There are two important reasons for teamwork. First, teamwork makes good management sense because it encourages collaboration among staff. As program plans develop, it is crucial to ask for the insights and opinions of everyone who will be affected by those plans, not just those who will have the responsibility for leadership in carrying them out. Second, teamwork ensures that the right combination of abilities and expertise will be applied to get the job done. This combination will vary from project to project, so it is crucial to clarify from the beginning the kinds of knowledge and skill required.

Teamwork strives to blend many perspectives.

Four characteristics define a team:

▶ *Team members have a common mission or charge.* The team must have a clear sense of the task at hand. At the outset of the process they may not know what the specific outcome of their collaboration will be, but they must have a common understanding of their point of departure.

▶ *Team members work interdependently.* This means that they cannot get the job done without contributions from every member. Sometimes staff will work alone or different staff may take turns carrying the ball, but the final product will be something created with the contributions of all.

▶ *Team members work toward common goals.* Everyone helps to develop the overall project goals. A team leader may have ultimate responsibility for the shape of those

goals, but the team as a whole must be confident that all perspectives will be taken into account in developing them.

▶ *Team members share accountability for the project.* Whether the project succeeds or fails, all members share in the outcome and should be recognized equally.

The role of team leader can vary according to the museum's organizational structure, the type of project the team is working on, and the project's stage of development. Several models for team leadership have emerged:

▶ *Content specialist as leader.* As specialists in a given field, curators are often in a good position to guide the conceptual development of an exhibit. Some curators

Team members share a common mission, work interdependently toward common goals, and share accountability for projects.

are fine communicators, and some—especially those from small institutions—have extensive experience in working with the public. Other curators, however, prefer the role of content specialist to the role of leader. They may feel that this role will give them more time to pursue their own research, or they may consider some aspects of exhibit development—such as overseeing the budget or the production and fabrication schedules—to be outside their area of expertise.

▶ *Audience specialist as leader.* Some museums are taking a "client-centered" approach to program and exhibit development, making visitor interests and needs the focal point of their planning. An audience specialist, such as a museum educator, is an appro-

priate choice for team leader when this is the guiding philosophy or when programs and exhibits are highly participatory.

▶ *Process specialist as leader.* Some institutions choose to establish a project management role for both the conceptual development and the implementation phases of their projects. This type of leader is concerned more with facilitating the decision-making process than with making content decisions. A process specialist may manage more than one project at a time. He or she has problem-solving and role clarification skills, as well as general program and financial management ability.

Just as leadership functions can vary, the team decision-making process can vary according to the phase of the project. Usually the team concept brings to mind

consensus decision-making. Given the variety of situations that might arise in a museum context, it may be impractical or unnecessary that this kind of agreement be reached. The following models for decision-making are useful in the program and exhibit development process.

▶ *Consensus decision.* All team members work together to reach a common idea or understanding. In the team approach to exhibit development, exhibit goals often evolve from consensus decisions.

▶ *Informed leader's decision.* It is the team leader's job to gather information and solicit ideas from team members, but the ultimate responsibility for making decisions belongs to the leader. Examples of informed leader's decisions are a judgment about the goals of a program or a decision about the opening date of an exhibit.

▶ *Democratic decision.* Simply put, this is a majority decision. This is not the best model for major decisions because it can result in an unfocused conclusion. Less complex decisions—when the next team meeting will be held, for example—are often democratic ones.

▶ *"From the top down" decision.* Sometimes teams implement administrative mandates. Examples of this type of decision include where an exhibit will be located, who will serve on an exhibit team, or when a program will start.

Sometimes the variety of skills and talents on a team leads to conflicting perspectives; in fact, that is an expected and even desired byproduct of teamwork. The natural creative tension between team members helps to assure that all points of view are considered. Creative tension must be managed well or it

will get out of hand. Consistent attention to role clarification, leadership structures, and formalized problem-solving techniques ensures that teams can work together effectively.

Activity 10, *Team Problem-solving Guide*, is a step-by-step approach to problem-solving.

Inevitably conflicts will arise in teamwork.

Voices from the Field

Clarifying Team Roles

The precise definition of each team member's role will depend on the subject matter and scope of the museum's collections, the kind of exhibit or program the team is developing, and the organizational structure of the institution. In general, however, any role has four aspects:

▶ *Role expectation* refers to the way team members interpret one another's responsibilities. Differing expectations among team members may be legitimate, or they may be the result of misinformation.

▶ *Role conception* refers to each team member's understanding of his or her own job on a team. Our conception of our own role is influenced by training, either through education or through professional experience.

▶ *Role acceptance* refers to the tasks each team member is willing to do. These might include responsibilities of special interest to a team member or new tasks that would enable a team member to expand his or her expertise.

▶ *Role behavior* refers to each member's actual function on a team or, if the team has not yet worked together, to each member's defined role.

This brief exercise is designed to ease the difficulty teams often have with role clarification. It is useful at the outset of the team process and for periodic role "checkups" during your time working together. The process will serve you best if your team works through responses for question 1 for each member, then moves on to question 2 for each member, and finally to questions 3 and 4.

Questions about Your Role

1. Ask *other team members* what they expect you to do. (What is your role expectation?)

2. Tell others what *you* think your job is. (What is your role conception?)

3. Describe what you are willing to do, both within and outside your specific job description. (What is your role acceptance?)

4. Tell others what you currently do. (What is your role behavior?)

There are four aspects to any person's role on a team.

80

Voices from the Field

The Hidden Agenda
A Play in Three Acts

Sometimes it is healthy to laugh at ourselves. When we point out our own foibles and see the humor in them, our working relationships can be more relaxed and our jobs can be easier. This skit takes a light-hearted look at some of the problems we commonly encounter in developing museum exhibits. It was performed during many of the Field Museum Kellogg Workshops on the team approach to exhibit development. Adapt it to your own museum for a bit of fun at an exhibit planning meeting. Discuss the kinds of stereotypes you see presented here.

The stage is bare, except for the players: the Curator, the Educator, and the Designer, each wearing identifying labels. The Curator wears a mortarboard and holds a diploma. The Designer wears a beret and holds a type specification book. The Educator wears Mouseketeer ears and holds a basket of touchable items. A fourth player, the Narrator, stands with them, wearing a label that reads, "What they really mean is. . . ."

Act I: Determining the Exhibit Concept

Curator: We have to do this exhibit on aphids. It's a burning issue.

Narrator: Five hundred aphid specialists are coming to a meeting in our town during the exhibit's run.

Curator: Everybody knows that this topic is an extremely significant aspect of this field.

Narrator: This was my thesis topic. My colleagues will be really impressed that I got this made into an exhibit.

Designer: How can I get interested in something so boring? And if I can't, what about the visitors?

Curator: I get hundreds of questions every year about aphids. The public will love this show!

Narrator: If we show Mr. Smith's collection, maybe the old tightwad will remember us in his will.

Educator: Why don't they ever ask me?

Curator: On the other hand, I'm not sure this exhibit is an appropriate concept for our museum to undertake.

Narrator: I don't have time to do it. Besides, it won't contribute to my tenure appointment.

Act II: Development and Fabrication

Curator: The designer is working on too many shows to be concerned with the exhibit concepts of this little display.

Narrator: Designers don't understand the importance of this message. They're not verbal people; they're artists.

Designer: Green will be just right for this exhibit of Irish aphids.

Narrator:	This is my chance to get rid of those 50 gallons of green paint left over in the basement.	Curator:	I'm sure that the director feels that I, as the subject matter specialist, have final responsibility for this exhibit.	Curator:	I'll have all the label copy next week.
Curator:	We should have a credit label so that researchers will know where to direct their questions.	Narrator:	I don't know anything about doing exhibits, but I'm in charge, so I'd better act authoritarian.	Narrator:	Ha! They'll be lucky if I'm through with it in a month. I've got lots more research to do.
Narrator:	I want my name on the wall.	Educator:	I think we ought to do a lecture on roses.		**Act III: The Exhibit Opening**
Educator:	This exhibit doesn't incorporate current pedagogical theory.	Narrator:	I don't know anything about aphids. Besides, I can get more people to come to hear about roses.		*For this scene, Curator, Educator, and Designer all hold champagne glasses. The Narrator moves off stage.*
Narrator:	This isn't my thesis topic. My advisor is going to hate it.	Curator:	I should have the final say on label copy.	Designer:	This show is not what I'd call a portfolio piece.
Curator:	The educator should be focusing on planning programs for after the exhibit opens.	Narrator:	The exhibit was my idea. I'm the only one who knows how to do it right.	Curator:	I don't like that shade of green.
Narrator:	She doesn't care beans about bugs. Besides, I want to write the labels.	Designer:	I can't give you an answer on layout right now. I have to do some more research.	Educator:	Why wasn't I consulted?
Designer:	Studies have shown that 12-point Bodoni is very legible.	Narrator:	I don't know what they really want, so I'll have to go on my intuition.	Designer:	If only we'd had another $10,000. We could have made it look really good.
Narrator:	Bodoni is very "in" this year.			Curator:	There's not enough stuff on display.

Educator:	Why isn't it participatory?
Curator:	If only the public relations department had advertised this exhibit there would be more people at the opening.
Educator:	Why is it so crowded? Where can I put a group?
Designer:	I should have been consulted before the concepts were settled.
Educator:	Why is it so dark?
Curator:	The light level is too bright. Everything will fade.
Designer:	Three footcandles? Zero is black!
Educator:	How am I going to do tours of this exhibit?
Curator:	I hope there aren't any mistakes in the label copy.
Educator:	Why are the labels so high?

Curator, designer, educator—do you know the stereotypes?

Curator:	Somebody edited my labels. They're too simple, and they're inaccurate.
Designer:	No one will read all this copy.
Educator:	Why is the print so small?
Curator:	The labels are so short my colleagues will think I'm a nitwit.
Educator:	Don't they know the general public reads at a seventh-grade reading level?
Curator:	How can I teach my graduate seminar in this hall?
Educator:	Where's the handout?
Curator:	The most important aphid is way in the back!
Educator:	How can I show this stuff on the sex life of aphids to school kids?
Curator:	That aphid is upside down!! And it should be in a climate-controlled case.

Educator:	How can the public ever relate to all this?
Designer:	The curator is always the star.
Curator:	My name isn't up on the wall.
Designer:	Layers of administration just get in the way of those who do the real work.
Curator:	I never wanted to do this exhibit in the first place.
Educator:	What was the point of this show, anyway?

Three enemies of the team approach are ego, turf, and success.

Evaluation for Decision-making

Exhibit and program evaluation is a crucial part of the team decision-making process. At its heart, evaluation is a management tool to assist institutions in making concrete decisions. These decisions may include which audiences an institution seeks to serve, what its program goals might be, how those goals can best be met, and how staff resources can be used effectively in the pursuit of goals. To develop an evaluation program for a particular project, the first step is to isolate the kinds of decisions we are currently facing. Then we can determine what information we need to help to make those decisions.

The rule of thumb in evaluation is, "Don't evaluate if you can't change it." Too often museums put a tremendous amount of time, effort, and money into evaluation only to find they cannot or do not use the results. The alternative is not to avoid evaluation, but rather to evaluate for the purpose of decision-making and to use evaluation early in the development of a project rather than later, when decisions may seem cast in stone.

We use evaluation to acquire two types of information to help in decision-making: information about the planning process and information about the product. Consider two familiar scenarios. In Scenario A, a program is developed by an impeccable process: Team members work together well, feel creative, and share responsibility, but their project is not successful with visitors. In Scenario B, the team produces a highly successful, perhaps even popular exhibit, but team members feel bitter, competitive, and drained of creativity. Although our commitment to public service may lead us to focus

Systematic evaluation of visitor behavior is crucial to decision-making.

85

on the negative consequences of Scenario A—low attendance, poor public perception of the institution, or low revenues—both scenarios are equally damaging. Clearly, we would like to achieve a third, optimum scenario in which both process and product succeed.

Evaluation can be formative or summative. Formative evaluation takes place in the early stages of a project; it might include testing exhibit mockups or label copy, conducting informal visitor studies, or meeting once a month as a team to assess the effectiveness of the team process. Summative evaluation occurs at the end of a project. It is often conducted to gather information that might be useful to future projects or to satisfy funding agency requirements. At the end of a long project, a team may discuss its experience to decide what the strengths and weaknesses of a particular working system and what future projects it might be appropriate for them to pursue.

Evaluation can be goal-referenced or goal-free. Goal-free evaluation is aimed at collecting as much information as possible to develop a topography of a given event or experience. It can be useful in developing project goals. It is also an excellent way to isolate unintended outcomes, whether potentially harmful or potentially valuable. The harmful outcomes can then be avoided, and the valuable outcomes can be stated explicitly as project goals. Goal-referenced evaluation uses project goals as a standard by which to measure success. Institutional planning goals and objectives are a guide when evaluating process, visitor experience goals and objectives when evaluating product.

New definitions of visitor experience in museums require a new strategy for measuring the success of that experience. Qualitative research offers a good model for evaluating the elusive visitor experience [Bogdan and Biklen, 1982]. It is being used more and more often in museum settings because its five characteristics are appropriate to the unique nature of our institutions. In qualitative research:

▶ The natural setting of an event is the direct source of data, and the researcher is the key instrument. The behavior of experimental subjects is not controlled; anthropology and not physical science is the model.

▶ Descriptions, not statistics, are the essence of the methodology.

▶ Process rather than product is the key. Researchers focus on understanding how the subject interviewed came up with an answer, not on the answer itself.

▶ The researcher uses inductive reasoning, developing the hypothesis and theory as the data are collected rather than testing a hypothesis using data collected for that purpose.

▶ "Meaning" is an essential concern. The researcher wants to determine what the experience is like for the subject, how the subject interprets it, and what the impact of the experience is.

The kind of evaluation you choose depends on what type of information you are looking for and whether your goal is to acquire information quickly or to take on a major research study. When we have developed program goals and objectives in concert with our institutional mission, evaluation can help us chart our progress and plan new directions.

Consult the list of *Further Reading* at the end of this book for a selection of good resources on evaluation.

School groups and casual visitors have different characteristics and needs.

Voices from the Field

Evaluation for Decision-making
A Case Study of the Field Museum
Kellogg Project

Evaluation is best undertaken in the service of concrete decision-making. In the Field Museum Kellogg Project, we faced three major questions: What kinds of issues should this project address? How can we use staff and faculty most effectively? What are the long-term training and professional development needs of the museum profession?

The Field's Kellogg project centered on two components. The workshops *Museum Education: Strategies for Effective Programming* involved museum educators and focused on establishing mission statements, goals, and objectives for education departments. In the workshops *Exhibit Development: A Team Approach,* teams of educators, curators, and exhibit designers learned how to apply a team approach to planning and carrying out exhibits in their museums.

From the beginning, evaluation was an integral part of our project. Before and after each workshop, we employed various strategies designed to yield feedback from project staff and workshop participants. We wanted to gather information in these areas:

▶ the participants' needs and interests;

▶ the participants' immediate reactions to the workshops;

▶ the impact of the project on participants over a period of nine months;

▶ the effectiveness of our planning process; and

▶ the impact of the project on the museum profession and the communities museums serve.

All this information was intended to help us make practical decisions about specific matters such as program content and about wide-ranging concerns such as the long-term training needs of the museum profession. Our evaluation strategies were both goal-referenced and goal-free. One of our project goals, for example, was to give participants information that would be of concrete use when they returned to their museums. To assess whether we were moving toward that goal, we asked participants to rate the usefulness of workshop sessions and, during follow-up evaluations, to cite examples of the project's impact on their work. We were also interested in understanding all the outcomes of our project, including those we had not necessarily planned.

The information we garnered from our evaluations influenced our decisions in important ways. First, it resulted in a redefinition of our project goals. At its inception, the Kellogg project consisted of what might be called "talking heads" workshops, with Field Museum staff instructing participants from other institutions. We had chosen this focus because the Field Museum Education Department receives so many requests for advice on how to plan and administer education programs, but after the first year of workshops we realized that it was not an appropriate structure. The challenges and opportunities museums face vary greatly depending on the nature of the institution—its location, budget and staff size, floor space, and collection strengths. Many Field Museum models are not easily translatable to other museums. As a result of our evaluation, our workshops evolved to take on a more participatory structure. Our new goal

was to provide the forum and the tools to help participants make their own decisions about running programs or developing exhibits based on the strengths and weaknesses of their own institutions.

This revised goal necessitated a number of concrete changes in the program agenda. We began to use keynote speakers from outside the Field Museum, arranged workshop topics thematically, and made a pedagogical shift to a problem-solving format using hypothetical activities. Our evaluation also showed us the need for faculty training. In the early stages of the workshop, Field Museum staff were usually asked to make half-hour presentations on assigned topics that related directly to their area of responsibility. But as we revised our format and the Field Museum became a forum rather than a model, it was clear that this system would no longer work. The project staff worked closely with faculty to help them expand their understanding of their own talents and

develop new teaching strategies. More faculty training was necessary with the new goals, and weekly meetings were held to test activities and ideas for presentations.

The third major outcome of our project evaluation is potentially wide ranging. We learned that many issues need to be put squarely on the agenda for further reflection and study both by staff members in individual institutions and by the museum profession as a whole. These are some of the issues our evaluation raised:

▶ *The extent of involvement by museum education departments, especially those in art museums, in the exhibit development process.* The largest percentage of participants in the Kellogg education workshops (33 percent) were from art museums, but only 16 percent of the exhibit workshop participants were from art museums. What are the possible reasons for this discrepancy? Does it suggest that while many art museums have active education departments, museum educators may not be included when exhibits are developed? Why might this be the case?

▶ *The definition of appropriate administrative "support" for program and exhibit development.* During our site visits we heard varying comments on the question of how

Getting the attention of a busy administrator can be difficult.

89

supportive the director is. Although administrative attitudes are key to the success of museum programs, what counts as "support" seems to differ from institution to institution. What are the "qualities" of support? How is "support" recognized and perceived?

▶ *The description of appropriate leadership for program and exhibit development.* Again, answers to this question vary widely. Who is in charge is an issue to be reckoned with in many museums; several leadership models have emerged, and the choice is up to the leadership individual institution. Can a team lead itself? Or does there need to be an appointed leader?

▶ *A shift from the "bandwagon" approach to developing exhibits and programs to a more cohesive approach.* In their museums, Kellogg participants are planning programs based on a clearer sense of audience interests and a more careful assessment of internal resources. Evaluation is one of their key interests. How do we establish appropriate criteria and select useful methods?

▶ *The importance of a problem-solving approach to program and exhibit development.* In our on-site study, we learned that most museums find it valuable to achieve a clear identification of problems and take a systematic approach to solving them. Institutions faced a variety of challenges, from new building projects to administrative reorganization. Those with clear lines of communication and well conceived goals were best prepared to solve problems. How can structured problem-solving methods become part of day-to-day operations?

Evaluation played a crucial role in the evolution of the Kellogg Project. By clearly identifying the questions we faced, we were able to target the kinds of information that would be most useful for program planning. Evaluation is the way our audience had a voice in the Project's development.

A problem is a difference between the current situation and the desired situation.

90

Summary

Museum staff are charged with bringing objects and visitors together. Fundamentally, this interpretive task involves creating contexts in which visitors can understand objects on display. The contexts we create are influenced by our personal values and professional commitments. Differing perspectives among team members sometimes fuel creativity and sometimes create conflict. Clarification of roles and structured problem-solving are techniques that help teams work together effectively. Evaluation of both process and product brings us full circle. It helps us determine how close we have come to our ultimate goal—creating encounters between objects and visitors.

©Kelen 1988

Success involves both working together effectively and producing something that is valuable to the visitor.

Activity 8

Reflecting on Personal Values

Purpose

Every museum has a set of institutional values; these values may or may not reflect the values of their professional staffs. Our audiences, too, have values and assumptions; sometimes we are aware of these and sometimes we are not. Add to this equation the unique sets of values and assumptions that we as individuals possess. Whether we realize it or not, we bring our own values to bear on the decisions and choices that we make every day in our museums. These personal perspectives can have a significant impact on the messages our museums send to visitors. Sometimes it is the imaginary, flight-of-fancy questions that most drive home who we are. Carry these questions with you and use them to get to know yourself and your colleagues a little better.

The goals of this activity are:

▶ *To help uncover the personal values that guide our views and decisions.*

▶ *To stimulate conversation with other museum staff about the role personal values play in their work.*

Method

1. *Answer the questionnaire on your own.*

2. *Think about what your answers tell you about your own personal values by discussing as a group or considering on your own the questions for group discussion. Don't feel that you must share your specific answers with the group.*

Personal Values Questionnaire

1. List up to ten adjectives that describe yourself.

2. Select five objects from your life that describe yourself.

3. What do you do for recreation?

4. What communities are you a part of?

5. What are you afraid of?

6. What was the last thing that made you really mad?

7. How do you like to be recognized for a job well done?

8. If you could designate your tax payments, what would they support?

9. If you won $5,000, what would you do with it? $50,000? $500,000?

10. Name the place where you would most like to go that you have never been before.

11. If you could have lunch with anyone living or dead, who would it be?

12. If you could choose any job in the world, what would you be doing, and why?

13. If you were marooned on a desert island for a year with three books and three records, what would they be?

Questions for Large-Group Discussion

1. *What kinds of personal values are reflected in your answers to these questions?*

2. *Traditionally, education has been used as a tool to transmit values from one generation to the next. Do we believe in our guts that people who do not share our values and assumptions ought to do so?*

3. *Is it our goal and our role as museum professionals to change people's attitudes and values to reflect our own or those of our institution?*

4. *Should museums guard and shape values? Whose values?*

This activity was created by

Robert Johnson,
Indianapolis Children's Museum

Sarah Kramer,
Knoxville Museum of Art

Jan Provenzano,
Rockford Art Museum

Betty Teller,
Smithsonian Institution Traveling Exhibition Service

Kevin Williams,
James Ford Bell Museum of Natural History.

Activity 9

Purpose

Our personal philosophy of education influences our approach to developing programs and exhibits, but often in ways we do not recognize and articulate. It is a valuable exercise to move our personal philosophy from a subconscious level to a conscious level and to find ways to make these ideas work to our best advantage. At times it is easier to see the assumptions in other people's programs.

The goals of this activity are:

▶ *To consider the relationship between philosophical ideas and practical decisions.*

▶ *To explore the consequences of this relationship for developing exhibits and programs.*

Method

1. *This is a group activity in two parts.*

2. *In part 1 (30 minutes), work as a team to develop funding guidelines for a new foundation, using the scenario provided. Then meet in a large group to discuss how each team member's personal values influenced the development of the guidelines.*

3. *In part 2 (45 minutes), review the hypothetical proposals in light of these guidelines. Then meet in a large group to discuss the questions below.*

94

Part 1

Your group is serving as the program review panel for a brand-new foundation. The foundation's primary interest is educational programs in museums. Each of you has been selected for the panel because of your expertise in developing and assessing programs. Since this is a new foundation, however, you have been asked to help develop funding guidelines. The review panel's job now is to develop a set of criteria for making grants, based on your ideas about museum education. The questions you must consider include: What kind of programs should be funded? What criteria should these programs meet? What qualities should a successful proposal have?

Part 2

The foundation has accepted the review panel's guidelines for museum education programs. Now it is time to start sharing the wealth. A stack of preliminary grant proposals has accumulated as you have been developing funding criteria. Review the four requests for funding on the basis of your guidelines and decide which programs you will fund. A consensus by the panel is not necessary. What is important is to discuss the merits of each application and consider how well it measures up to your criteria. The *reasons behind your decision to approve or deny funding,* not the decision itself, are the central issue in this activity.

Request for Funding 1
Oceanside Museum of Natural History
Self-Guide for "Peoples of Hawaii"

Late next year the Oceanside Museum of Natural History will open its newest permanent exhibit, *Peoples of Hawaii.* To assist the casual visitor in interpreting this exhibit in greater detail than the exhibit labels alone allow, we request funding to produce four self-guides to *Peoples of Hawaii.* Each self-guide will address a specific exhibit theme: food, shelter, clothing, and social organization.

All self-guides will be written by a professional writer with expertise in the subject area, hired by our Education Department solely for this project. In addition, each guide will be reviewed for completeness and accuracy by the exhibit curator and a panel of other staff anthropologists. Because we expect most users to be adults, the self-guides will be written at a high school reading level. A secondary

audience for these guides will be teachers, who can use them as aids in touring their students through the exhibit.

All four self-guides for *Peoples of Hawaii* will follow a basic format:

▶ diagram and map of exhibit showing the location of cases and individual objects relevant to the self-guide theme

▶ introduction to the exhibit

▶ narrative describing the historical and anthropological significance of the cases and objects (coded to the diagram and map)

▶ short annotated bibliography for the visitor who wishes to pursue this topic further at his or her leisure

In addition, one or two photographs from our archives will illustrate each self-guide. None of the self-guides will exceed six printed pages. We are interested in providing as much detailed information as possible. Self-guides will be available to the public free of charge in wall holders placed at several locations throughout the exhibit.

In the last four years, school group attendance at Appleseed Farm and County Historical Society has increased by 58 percent; just over 12,000 schoolchildren now visit our site each year. The demand for tours of our exhibits far exceeds what our one-and-one-half-person staff and six-person volunteer corps can provide. We therefore request funding for a program to teach teachers how to be comfortable conducting a tour of our site themselves.

Our proposed program for teachers will be a five-day summer session held at AFCHS. During the course of the workshop, to be conducted by our education staff person, teachers will learn:

▶ the history of Appleseed County and background on the founding of the historical society;

▶ an overview of the exhibits on our site, in the farmhouse, barn, and other outbuildings;

▶ the importance of agriculture in 19th-century Appleseed County and where farming fits into our county's economy today;

▶ techniques for using our exhibits to help students develop their perceptual and critical thinking, as well as their subject matter skills; and

▶ considerations for planning and preparing for a successful field trip.

Most important, teachers will learn that they do not have to be "experts" in history (or interior design, rural architecture, agriculture, biology, earth science, folklore, or anthropology) to conduct a successful field trip focused on practically any theme. During the workshop, we also plan to describe related resources, available through AFCHS, that can help them plan for or follow up a field trip to our site. These resources include suitcase kits and previsit planning sheets.

During this workshop we will employ a variety of instructional techniques, including role playing, lecture-discussion, hands-on practice, and peer teaching. We will also encourage the participants to share ideas about what has and has not worked for them on field trips they have organized in the past.

Request for Funding 3
Kane Public Museum
Gallery Kit

Ten years ago, the Kane Public Museum received a bequest from a local collector— a small collection of art from ancient Egypt, Greece, Mesopotamia, and Rome. These pieces have been permanently installed in a gallery titled the Ancient Art Gallery, where visitors can simulate the methods of archeological investigation, learn about the history of ancient cultures, and do something fun together as a family.

The purpose of the gallery kit is to encourage families to look carefully at the objects on display and to think about what kinds of information they can obtain from the objects. The gallery kit will contain:

▶ a suitcase designed to resemble an archeologist's trunk containing three fragments (cast replicas) from different objects in the Ancient Art Gallery: a segment of an Etruscan mural, a finger from a Greek statue, and a scarab from an Egyptian necklace;

▶ a comic-book-style guide or logbook that will provide instructions and clues to aid in identifying the fragments and matching them with the objects that are on display in their entirety. The book will provide a place for families to record their observations. It will be something they can take home as a souvenir of their visit;

▶ an exhibit map;

▶ "archeologists' equipment": clipboard, pencil, ruler; and

▶ an instruction sheet.

The gallery kit will be available free of charge for families' use during their visit to the Ancient Art Gallery, but it must be returned to the information desk before they leave the museum.

Request for Funding 4
Oak Leaf Art Center
Learner's packet to accompany special exhibit lecture series

We plan to offer a six-part lecture series on "The Arts of Belgium" to broaden visitor appreciation and understanding of the extraordinary range of artistic accomplishment represented in the upcoming exhibitions we will be hosting in 1989: *Belgium: Two Hundred Years of Lacemaking* and *From Endive to Waffles: Belgian Cuisine.*

Realizing that the lectures will encompass complex art historical and culinary information unfamiliar to most members of our audience, we request funding to develop a learner's packet to provide easy access to reference information and to encourage further self-directed learning in

these areas. The learner's packet will include the following materials:

▶ a glossary of key terms;

▶ a pronunciation guide for Belgian and other European cuisines

▶ a 10- to 12-page narrative highlighting major pieces in each exhibition;

▶ a transcript of a related lecture on art of the Low Countries delivered at the Oak Leaf Art Center last spring;

▶ an annotated bibliography of recommended general and specialized texts in the fields of Belgian art, science, technology, history, literature, and religion;

▶ a map with major cities, craft centers, and restaurants of Belgium;

▶ a participant questionnaire for use in evaluating the lecture series/learner's packet program; and

▶ instructions for make-at-home lace projects and a selection of Belgian recipes to encourage lifelong learning in the subject areas of each exhibit.

The learner's packets will be distributed free of charge to lecture series participants over a six-week period. Local scholars, local public library staff, and six lecturers with whom we have contracted will render assistance in assessing the materials for content, accuracy, and coherency of presentation, but on the whole, the education staff will have primary responsibility for research and writing.

Questions for Large-Group Discussion

1. *How did you determine whether a proposed program fit within your guidelines?*

2. *If you rejected a proposal, did you do so in part because it seemed to reflect a philosophy of museum education different from yours? What philosophy did it reflect?*

3. *What assumptions did the authors of the proposals make about education or about visitors?*

Activity 10

Team Problem-solving Guide

Purpose

Years of trouble-shooting in the hectic world of museums have given most of us good instincts about problem-solving. But in many situations, a more systematic approach to solving problems can be useful. When we work independently, a structured approach can help us organize our thinking and formulate clear concepts that support our instincts. We can then explore all possible options to find a solution, and we can communicate our ideas and rationales better to those who will be affected by our decisions. When we work as a team, a structured approach helps team members develop a common understanding of the problem and a common vocabulary for solving it. We have a framework for ensuring that all perspectives on a problem are heard.

The goals of this activity are:

▶ *To strengthen team problem-solving skills and provide a conceptual framework and common vocabulary for team problem-solving activities.*

▶ *To give a team the opportunity to work on a problem they currently face at their institution.*

Method

1. *This guide is designed for use by a working team. It can also be adapted for individual use.*

2. *Call a meeting designated for team problem-solving. Distribute copies of this guide in advance to those who will be attending. Ask them to read the guide thoroughly, choose a problem they are facing, and complete the first two steps of the guide before the meeting. Be sure that each member chooses a problem that is the team's responsibility to solve, not an individual's responsibility.*

3. *Begin to work through the problem-solving process, using this guide as an agenda for your meetings. Work on Steps 1 and 2 independently; then bring the individual statements together to the team for discussion.*

4. *Work at a pace that suits your team; you may not finish all the steps in one meeting. Have one person on the team keep a record of your discussions.*

99

Step 1
Developing a Problem Statement

A major part of any problem-solving effort involves identifying the problem correctly. In team problem-solving, problem identification is complicated by the fact that different team members may have different perspectives on what a problem is and which ones are important.

Begin by writing a rough draft of your problem statement. Briefly describe a problem you are now facing in your museum. Be as specific and succinct as possible. Include comments on factors that you think contribute to your problem and solutions you have attempted unsuccessfully.

The real work in problem-solving comes in clarifying your description of the problem and analyzing possible causes. Now the aim is to use your draft statement as a starting point and state your problem in a clear, workable form. To begin, consider these definitions.

▶ A problem is a difference between what actually is and what should be.

▶ A problem is the situation you have on your hands.

▶ A cause is the reason for the situation.

▶ A solution is what you do about it.

Carefully describing what the situation actually is keeps us from foreclosing on a host of possible solutions. For example, suppose that as the day begins, you are dragging your feet and you can't seem to get going. You think that your problem is a lack of sleep. But if you take a moment, you realize that you are tired: That is the current situation; that is the problem. Lack of sleep is the cause of the problem. Finishing the day's big project with focused energy and attention is the desired situation. Stating the problem as a factual description of the current situation might help you expand your options for a solution (you could have a cup of coffee, take a brisk shower, go for a jog, or crawl back into bed.) This rather trivial example is meant to illustrate an important point: Identifying the problem correctly is not as easy as it seems, but it is crucial to coming up with a workable solution.

Look at your draft problem statement. Revise your description by answering these two questions:

▶ What is the desired situation?

▶ What is the current situation?

These questions will help you pry loose facts about your problem. Describing a problem with facts helps prevent problem-solving discussions from becoming conflicts of personality or attitude. If you have the facts, you will be much better able to work toward resolution of the problem.

Describe the desired situation with observable, objective statements of events and behaviors. Then express the problem in terms of observed deviations from that standard or norm. Be sure to distinguish fact from assumption in your problem description. Stating your problem in terms of specific demonstrated behaviors—not attitudes—helps ensure that you are dealing with facts. For example, "This team lacks commitment to the project" is an assumption about an attitude. A description about the facts might be, "This team fails to hold to its schedule of regular team meetings and missed two important deadlines last month." Our assumptions about the attitudes of others are not always accurate. By stating facts, you develop solutions to your problems that are focused on changing concrete behavior. If you must use assumptions, note they are just that.

Now review your answers to the questions above. Are they phrased in observable, objective statements of events and behaviors? Are your assumptions clearly noted? When you are satisfied with your answers, move on to Step 2.

Step 2
Determine Whether Your Problem is Worth Solving

Common sense says, "If you have a problem, solve it!" But some problems are not as important as others, and some are not solvable. The difficulty is deciding which problems to solve. To help with this decision, think about your problem in relation to these five sets of questions:

▶ If I don't act will the problem go away? Will it stay the same? Will the situation worsen?

▶ What does the problem cost me? What does it cost my organization? What happens if I don't solve it?

▶ What happens if I solve it? What are the benefits to my organization?

▶ How badly does it hurt? Which is more important, solving this problem or devoting my energy to something else?

▶ Will I be able to act on this problem? Does it require my expertise? Do I have the knowledge and authority necessary to work toward a solution?

Each team member should consider his or her problem in light of these five sets of questions. Although you need not write an answer to every question, jotting some notes to yourself will give you more data about your situation and help you decide where your problem stands among your other priorities. If you are sure it is worthwhile to solve your problem, move on to Step 3.

Step 3
Select the Problem That Is First Priority and Analyze It

Now the essence of teamwork begins. In a group session, each team member should describe his or her problem using the information collected in Steps 1 and 2. Try to explain why you think your problem is worth solving. List all team members' contributions on a sheet of newsprint.

Discuss the problems listed. Focus on getting a clear view of each team member's perspective. Although critical judgement will be crucial to problem-solving, this is a time to suspend judgment and understand the views of others. Help create an accepting, inventive mood in your team. Disagreement may be inevitable, but make it a constructive experience that contributes to the health and creativity of your team. Let questions and conflicts take the following form:

"I disagree with you and I want to find out. . . .

▶ Do I understand your viewpoint correctly?

▶ What assumptions, opinions, or facts cause you to take that point of view?

▶ What information can we request from available resources to help our inquiry?"

During the discussion you may paraphrase what you have heard and have others correct your understanding; inquire into the assumptions, opinions, or facts expressed by your fellow team members; or invite others to do the same with you.

After the discussion, you can begin to decide the priority of your problems. There may be no disagreement about which of the problems is most important, or you may all have described the same problem. If you can not reach a consensus, try making a majority-rule decision. Each team member assigns a point value to the problems: three points to the most urgent and solvable problem, two points to the second priority, and one to the lowest priority. Tally the points and work on the problem with the highest point value.

Problem analysis is the next aspect of the process. If you begin to solve the problem immediately, your solutions may be superficial because you have not analyzed the problem thoroughly. Analyzing a problem involves breaking it into its parts.

Questions phrased in terms of who, what, when, where, why, how much, and how often are useful here because they evoke concrete answers that give you a deeper understanding of your problem and lead to realistic solutions.

Working as a group, consider these following questions in analyzing your problem. You began this process when you answered questions 1 and 2 during Step 1. Write your answers on a sheet of newsprint. The more specific your answers are, the greater are your chances for developing a clear and practical solution to your problem.

▶ *What is the current situation?* This question will help you pinpoint the problem through an objective statement of the facts that make up the existing situation.

▶ *What is causing the current situation?* This question will help you pinpoint factors contributing to the problem. Try to look for a variety of possible reasons.

▶ *What is the desired situation?* This question will help you specify what you want the improved situation to be. The contrast between the existing and the desired situations will lead to your decision about the best solution.

▶ *What has to change to achieve the desired situation?* This question will help you specify what you need in order to solve your problem. Specifying a means of achieving what you need is a later step.

If you are satisfied with your answers, move on to Step 4.

Step 4
Determining Restrictions on Solutions

It is inefficient to try to solve a problem before you consider the restrictions on your actions. Restrictions are the limits or constraints that affect how you can solve the problem. In team problem-solving we are often not aware of the restrictions other team members may face. One member may know, for example, that you can spend no more than $3000 on your solution; another may realize that you have only two months in which to implement it. If the restrictions are fixed, don't spend time dreaming up "if only" solutions—"If only I had more time. . . " or "If only I had more money."

List the potential restrictions you see facing you and your institution. Possible considerations include financial constraints, time limits, personnel requirements, and space limitations. Be as specific as possible by listing how many staff or how much money, time, or space you have available to you. By establishing boundaries, you are more assured of finding a workable solution. Once you have established those boundaries, move on to Step 5.

Step 5
Examine Possible Solutions

A solution is a course of action that brings about change. Its result is to eliminate the discrepancy between the current and the desired situations, between what exists and what should exist. If it merely reduces this discrepancy, it is a partial solution. The emphasis here is on the plural: *solutions.* By looking for more than one solution, you will expand your available options. There is no guarantee your best idea will be your first, your second, or even your third.

As you try to formulate a solution, you may draw on a number of possible sources. Your fellow team members are the most obvious choice; other good sources are your colleagues, your subordinates, your boss, and your own past experience. A variety of sources may yield a variety of solutions. You may also uncover a solution in an institutional policy or procedure that you did not know about.

Begin your search for solutions by brainstorming in your team. All ideas are welcome—even the most outlandish. Build a full collection of potential solutions first. Then identify the solutions that are not feasible—along with the specific restriction that makes each one unworkable—and eliminate them from your list. Next, examine the advantages and disadvantages of each solution. List the pros and cons on a piece of newsprint.

Now you are ready to move on to Step 6.

Step 6
Decide How to Implement and Evaluate the Best Solution

Three questions can help you determine a plan of action.

▶ *Which solution seems the best to my team members and me?* Choosing the best solution is a tricky business. Your choice should be based on your analysis of the pros and cons of each possible solution and your consideration of how well each solution would lead toward the desired situation you described in Step 3. You may want to pick a combination of solutions to best address your problem. In making your choice, consider such factors as:

— the original purpose for problem-solving;

— the effects of the solution on the quality of your work and the operation of your institution;

— the needs and opinions of your supervisor and your staff;

— the solution's feasibility and practicality; and

— the goals and objectives of your museum, department, or project.

As a team select the solutions that seem best to you. You may want to pick a combination of solutions to best address your problem.

▶ *How will I implement the solution?* Determining a plan for implementation involves three activities: establishing the steps; anticipating possible roadblocks; and altering or improving the plan to nullify the effects of those roadblocks.

On a sheet of newsprint, develop a step-by-step action plan that incorporates these activities. As you describe your steps, be sure to include names of individuals responsible for each task and the dates by which the tasks are to be completed.

▶ *How will I prove the solution worked?* Good ideas are abundant; good solutions are hard to come by. This question forces you to find ways to measure the effectiveness of your solution. Keep these two important points in mind: Use quantitative measures whenever possible, and be

specific. State the desired outcomes in terms of specific behaviors—numbers, dates, times, individuals involved. If your problem is a shortage of new volunteers, for example,an effective measurement of the success of your solution might be: Joan will be able to recruit 10 new volunteers by May 15 without increasing the current promotion budget by more than 2%.

List your yardsticks for a successful solution. From this list develop a concrete plan stating who should make the measurements, how often, and by when. Assign responsibilities for each step in the plan.

Once you have developed a clear plan of action and criteria for evaluation you are ready to move on to Step 7.

Step 7
Implement the Solution and Follow Up With Documentation

In a sense, there is little more to say about implementing your plan except, Do it! Put the plan into action and reap the benefits of your hard work. We all know how many good plans are just plans on paper that collect dust on already crowded shelves. But after carefully conquering each of the first six steps in this guide, you will have enthusiasm for and commitment to your solution, as well as confidence in its feasibility and your own skills. Presenting your work to your supervisor and staff can help them buy into your solution, too.

Once the plan is implemented, remember to evaluate the success of the solution using the method you developed in Step 6. If the solution is meeting your expectations even though the results are slow in coming, keep implementing the plan. If the solution is not meeting your expectations and the problem still exists, work through the problem-solving process again to attain a new solution. The information you have gained through your attempted solution will give you a new perspective on the problem.

As you monitor your plan, document your findings. Documentation will put you in a better position to analyze the results and decide what your next steps should be.

Reference

Appendix A:

*Planning a Professional
Development Workshop*

Open Conversations is designed to be a guide to discussion for museum professionals. Use it as a resource for planning a professional development workshop for your staff and colleagues. The suggestions below are intended to help make your session a great success.

Identify Your Audience and Get the Word Out

▶ Decide who you would like to invite to your session. For example, would you like to plan a session for your department staff, your museum staff, a city-wide group of colleagues, or participants at an annual professional meeting?

▶ Choose a theme for your workshop. If possible, include potential participants in your planning. Contact them and ask for suggestions for a theme.

▶ Choose a date and time for your session and check it out with potential participants.

Plan the Session

▶ Read through *Open Conversations* to find materials that would be appropriate to your audience. Keep in mind their experience level and role within the institution.

▶ Choose an activity for your workshop. Work through it on your own. Ask yourself these questions: What issues are most important to you in it? How does the situation presented relate to your on-the-job experience? Are there questions you would like to add to the topics for discussion? How long does the activity take?

▶ Develop goals and an agenda for your session.

▶ Prepare materials for the session. Photocopy all the pages for your chosen activity; these will serve as your hand-outs for the workshop. Since all the activities relate to the text of *Open Conversations*, you may want to duplicate sections of the text to distribute to session participants. You will also want to collect together other materials like large newsprint paper and markers.

▶ Formally invite participants. Distribute a note or memo inviting people to the workshop. Attach your chosen sections of the Open Conversations text to help them prepare.

Leading the Session

▶ Write the goals of the session on a flip chart or blackboard before participants arrive.

▶ Begin with participant introductions if the members of your group have not met before.

▶ Show participants the flip chart and state the goals of your session. If participants have been given copies of the *Open Conversations* text prior to the workshop, begin with a brief discussion of the text.

▶ Use the Purpose statement on your chosen activity page to introduce your activity. You may want to read it as it is in the text, or you may want to adapt it to your own style.

▶ State the goals of the activity to participants. Explain the method of the activity. Ask for questions to make sure your directions are clear. State how much time participants will have to complete the activity. If it is a two-part activity, state the time allotment for each part.

▶ Distribute your hand-outs and break the participants into groups. After everyone has had a chance to read the hand-outs ask for questions again.

▶ Circulate among the groups to help with any problems or confusions that arise. If they are working on a two-part activity tell them when it is time to move on to the second part.

▶ After everyone is finished (or when your allotted time is up) direct their attention back to you. Begin a discussion of the questions listed on the activity. Ask participants to compare the hypothetical situation to their own experience; Does it help them see that experience in a new way? As the discussion proceeds, listen for participants to say things that reinforce the goals of the activity. Make a note of these comments.

▶ Summarize the activity. Refer to comments that others have made that support to the goals of the activity. You can also ask participants to summarize the activity for you. Ask one or two people to state what they learned from the session.

▶ Do a "quickie" evaluation. Pass out sheets of blank paper and ask participants to rate the session on a scale of one to five for usefulness. Ask them to write down one new thing they learned and one way they think the session could be improved.

Follow Up with Future Sessions

▶ Set up a time for a future meeting. You may want to have rotating leadership, each person responsible for presenting different materials.

▶ Read over the evaluations and your personal notes. Make a note of parts of the activity that didn't run smoothly along with suggestions on how to change them.

Appendix B

Robert J. Barber
Children's Museum of Houston
Houston, Texas

Terry Boykie
New York Hall of Science
Corona, New York

Lucinda Bray
Kansas Museum of History
Topeka, Kansas

David Brown
Academy of Natural Sciences
Philadelphia, Pennsylvania

Rebecca A. Burton
Idaho Museum of Natural History
Pocatello, Idaho

D. Beth Bussey
Omniplex Science Museum
Oklahoma City, Oklahoma

Marlene Chambers
Denver Art Museum
Denver, Colorado

Susan Childs
Los Angeles Children's Museum
Los Angeles, California

Wanda Chin
University of Alaska Museum
Fairbanks, Alaska

Janet Cooke
Montclair Art Museum
Montclair, New Jersey

Mary Cummings
Missoula Museum of the Arts
Missoula, Montana

Susan Curran
Field Museum of Natural History
Chicago, Illinois

Jean DeMouthe
California Academy of Sciences
San Francisco, California

Susan E. Douglas
California Academy of Sciences
San Francisco, California

Ellen Dugan
High Museum of Art
Atlanta, Georgia

Nancy Evans
Field Museum of Natural History
Chicago, Illinois

Susan Finkel
New Jersey State Museum
Trenton, New Jersey

Phil Hanson
Field Museum of Natural History
Chicago, Illinois

Marie Hewett
Strong Museum
Rochester, New York

Dona W. Horowitz
Please Touch Museum
Philadelphia, Pennsylvania

Kimi Hosoume
Lawrence Hall of Science
Berkeley, California

Susan K. Jagoda
Lawrence Hall of Science
Berkeley, California

Robert W. Johnson
Children's Museum
Indianapolis, Indiana

Karen B. King
Charleston Museum
Charleston, South Carolina

Sharon Kokot
Columbus Museum of Art
Columbus, Ohio

Richard Kool
Royal British Columbia Museum
Victoria, British Columbia

Sarah H. Kramer
Knoxville Museum of Art
Knoxville, Tennessee

Linda Grandke Kulik
California Academy of Sciences
San Francisco, California

Joyce Matuszewich
Field Museum of Natural History
Chicago, Illinois

Michael McColly
Field Museum of Natural History
Chicago, Illinois

Vicky Middleswarth
Kentucky Historical Society
Frankfort, Kentucky

Juanita Moore
National Afro-American Museum
Columbus, Ohio

Kelly Nolte
Jamestown Festival Park
Williamsburg, Virginia

Terry O'Connor
Woodland Park Zoo
Seattle, Washington

Steven L. Olsen
Museum of Church History and Art
Salt Lake City, Utah

Audrey Janet Olson
Roswell Museum and Art Center
Roswell, New Mexico

Janet D. Pawlukiewicz
National Museum of Natural History
Washington, D.C.

Nancy S. Perry
Jamestown-Yorktown Foundation
Williamsburg, Virginia

Kathleen Plourd
Glensheen
Duluth, Minnesota

Ellen Plummer
Artrain, Inc.
Ann Arbor, Michigan

James L. Powers
Kansas State Historical Society
Topeka, Kansas

Jan M. Provenzano
Rockford Art Museum
Rockford, Illinois

Phyllis Rabineau
Field Museum of Natural History
Chicago, Illinois

Jean Robertson
Columbus Museum of Art
Columbus, Ohio

Maija Sedzielarz
Field Museum of Natural History
Chicago, Illinois

Carol Bruce Shannon
City of Colorado Springs Pioneers' Museum
Colorado Springs, Colorado

Beverly Black Sheppard
Historic Museums Consortium of Chester and
Delaware Counties
West Chester, Pennsylvania

Helen Sheridan
Kalamazoo Institute of Arts
Kalamazoo, Michigan

Kathy Sider
Seattle Aquarium
Seattle, Washington

Arn Slettebak
Burke Museum
Seattle, Washington

Susan Stob
Field Museum of Natural History
Chicago, Illinois

Betty Teller
Smithsonian Institution Traveling Exhibition Service
Washington, D.C.

John Terrell
Field Museum of Natural History
Chicago, Illinois

Thomas C. Thompson
Minnesota Historical Society
St. Paul, Minnesota

Peggy Tolbert
Snite Museum of Art
Notre Dame, Indiana

Alexia Trzyna
Field Museum of Natural History
Chicago, Illinois

Judith Vismara
Field Museum of Natural History
Chicago, Illinois

Ralph A. Wilke, Jr.
St. Louis Science Center
St. Louis, Missouri

Kevin Williams
James Ford Bell Museum of Natural History
Minneapolis, Minnesota

Robert Wolk
North Carolina State Museum of Natural Sciences
Raleigh, North Carolina

Robert M. Woltman
Albuquerque Museum
Albuquerque, New Mexico

Ellen Zebrun
Field Museum of Natural History
Chicago, Illinois

Appendix C

Arts, Sciences, and Technology Center
Vancouver, British Columbia

Burnett Park Zoo
Syracuse, New York

California Academy of Sciences
San Francisco, California

Charleston Museum
Charleston, South Carolina

Children's Museum
Indianapolis, Indiana

Children's Museum
Portland, Oregon

Cincinnati Museum of Natural History
Cincinnati, Ohio

Columbus Museum of Art
Columbus, Ohio

Denver Art Museum
Denver, Colorado

Denver Museum of Natural History
Denver, Colorado

Drayton Hall
Charleston, South Carolina

Franklin Institute Science Museum
Philadelphia, Pennsylvania

Fort Wayne Children's Zoo
Fort Wayne, Indiana

High Museum of Art
Atlanta, Georgia

Kalamazoo Institute of Arts
Kalamazoo, Michigan

Lakeview Museum of Arts and Sciences
Peoria, Illinois

Loveland Museum and Gallery
Loveland, Ohio

Michigan Historical Society
Lansing, Michigan

Minnesota Historical Society
St. Paul, Minnesota

Mississippi State Historical Museum
Jackson, Mississippi

Missoula Museum of the Arts
Missoula, Montana

Montana Historical Society
Helena, Montana

Museum of Florida History
Tallahassee, Florida

Natural History Museum of
Los Angeles County
Los Angeles, California

Nebraska State Historical Society
Lincoln, Nebraska

New Jersey State Museum
Trenton, New Jersey

New York Hall of Science
Corona, New York

Oregon Historical Society
Portland, Oregon

Please Touch Museum
Philadelphia, Pennsylvania

Riverside County Parks
Riverside, California

Royal British Columbia Museum
Victoria, British Columbia

Royal Ontario Museum
Toronto, Ontario

Seattle Aquarium
Seattle, Washington

Appendix D

Jennifer Agnew
James Aiello
Shirley Albright
D. Roy Alexander
Paul A. Anderson
Jackson Andrews
Bill Atkins
Amanda Austin
Lorraine Austin
Linda Bahm
Li Bailey
Marylou Baker
John Barber
Patricia Barnicle
Allen Bassing
Jennifer Bayles
Leslie Bedford
Jacalyn Bedworth
Susan Bernstein
Lynn Bird
Deborah S. Bishop
Linda Black
Judith Bobenage
Kathryn A. Bohling
Marsha Bol
Jeffery P. Bonner
William Booker
Desne Border
Patricia Boutelle
Terry S. Boykie
Betty Bradlyn
Suzanne Brandon
Karen Broenneke
Gary Brookfield
John Brooks
David Brown
Charlotte Brown
Jerry K. Brown
Robert M. Brown
Rick Budd

Robert Bunkin
David Burney
Jay C. Burns
Rebecca A. Burton
Bonnie Busenberg
D. Beth Bussey
David Butler
Patrick Butler
Danuta Bytnerowicz
Betty Dunckel Camp
Barbara E. Campbell
Dorothy M. Cantor
Tamra Carboni
Nancy Carlisle
Nancy Carnes
Charlene Cerny
Dyana Chadwick
Carol Chamberlain
Marlene Chambers
Jan Chapman
Valerie Chase
Elaine Cheeseman
Mark Chepp
Timothy Chester
Susan Childs
Eleanor Chin
Wanda Chin
Joseph Chipman
Karen Choppa
Donna Claiborne
Bohdanna Cmoc
Kathryn Coates
Mary Coles
Joy Comstock
E. Jane Connell
Wallace Conway
Janet Cooke
Christopher Cooksy
Cherrie Corey
Robert C. Cottrell
Shirley Cox

Bruce Crabe
Lisa Cresson
Mary Cronin
Frank B. Cross
Cynthia Crow
Mary Cummings
David Curry
Alan Cutler
Carol Dalpe
George Ann Danehower
Edie Davidson
Marilyn Davidson
R. A. Davis
Amy L. Dawson
Cory Dawson-Tibbits
Elizabeth Dear
Louise DeMars
Jean F. DeMouthe
Cornelia Denker
Brent Dennis
Gail L. Dennis
Laurie C. Dickens
Anne Digan
Karen Dillon
Marianne Doezema
B. Lynn Doggett
Wendy Donawa
Susan Douglas
Edward Dudek
Ellen Dugan
Carol J. Eames
Elizabeth Eder
Svein Edland
Barry Eichinger
Laura Eisen
Victor Elderton
Gary Elsey
Philip Elwert
Donna Engard
Len Epstein

Jim Erickson
Mary Erickson
Eugenio Espinosa
Sue Evans-Olson
Harmon Everett
Vicki Everson
Pauline Eyerly
Carla Fantozzi
Lola Farber
David Featherstone
Juanita Ferguson
Mike Feyers
Paul Figueroa
Susan Finkel
Bob Flasher
Veeva Fletcher
Eileen Flory
Penny Foldenaner
Karl Forage
Phyllis Foster
Rebecca A. Foster
Terri Fox
Linda Franklin
Darlyne Franzen
Lorrae Carol Fuentes
Sue Fuller
Joseph Fury
Charles Garoian
David Garrison
Ruth Gebel
Janet Gelman
Ruth H. Gennrich
Steve Germann
Mary Gesicki
Judith Gibbs
Billy Goodman
Deborah Goodman
Joan Grasty
Frannie Greenberg
Sue Griswold
Barbara Grubb

Thomas Guderjan
James Hagler
Barbara Hamblett
Beverlye Hancock
Ron Hand
William Hanshumaker
Signe Hanson
Lynette Harper
Barbara Harvey
Brian Hassan
Mary Heininger
Judy Herman
John Hernandez
Joyce Herold
Jane Herrman
Marie Hewett
Karen Hickerson
Bill Hill
Maureen Hill
Chriss Holderness
Jeannine Holdiman
Frank Hole
June Holly
Peggy Holsten
Laura Hood Nichols
Dona Horowitz
Kimi Hosoume
Pamela Houk
Jim Houser
Mary Houts
Nora Howard
Kevin Howe
Sarah Hughes
Donald Hughes
Rebecca Hunt
David Imbrogno
Roree Iris-Williams
Susan P. Ison
Susan Jagoda
Rick Jannett
Frank Jewell
Grace Johnson

Lee Johnson
James H. Johnson
Janet Johnson
Robert Johnson
Ed Jonas
Edward Jones
Grayson Jones
Tom Kasimpalis
Rebecca Keim
David Kelley
Patricia Kelley
Linda Keltner
David Kemble
Jeff Keogh
Donna Kindig
Karen King
Craig Kirby
Deborah Klochko
Carol Knauss
Sharon Kokot
Richard Kool
Sarah Kramer
Liz Kregloe
Martha Krom
Jamey Kugler
Linda Kulik
K. D. Kurutz
Bryan W. Kwapil
Mary Kwas
LeeAnn Labby
William Lampe
Sarah Larsen
Meggett Lavin
James Lawton
Thomas Leary
Maria Leiby
Geoffrey Levin
Daniel Levitt
Shabtay Levy
Mary Lohrenz
Torii Long

Pamela Lowell
Don Luce
Jack Lufkin
Jane Lyons
Laura E. Lyons
Modesto Maisonet
Ann Mandolini
Lori Mann
Tony Mares
Garry Marlow
Robert Martin
Lynda Martin
David Maschino
Joan Maske
Dennis McAndrew
Lynne McCall
Susan L. McCauley
Dan McClelland
Mary McConnell
Nancy McCoy
Bobbie McGee-Benson
Barbara McGregor
George McIntosh
Bill McKee
Phyllis McKenzie
Laura McKie
Jack McKinney
John McKirahan
Lee McLaird
Janice Victoria McLean
Suzanne McLeod
C. Robert McNiel
Ron McRae
Alberto Meloni
Mark Meneghetti
Dorothy Merrill
Sarah Mickel
Victoria Middleswarth
Christopher Migliaccio
Mimi C. Miley
Bruce Miller
Cynthia Miller

Patrick Minor
Michael Monroe
Joseph Moore
Juanita Moore
Cynthia Moreno
Ann Morrison
Chris Moser
Fran Moskovitz
Leslie Munro
Gordon Murdock
Patrick Murphy
Christine Murry-Miller
Pamela Myers
Susan Myers
Ellen Myette
Momi Naughton
Kristine Nelson
Julia Nelson-Gal
Richard Nemeth
Regina Neu
Anne Newlands
Virginia Newman
Kay Nichols
Penelope Nichols-Dietric
Kelly Nolte
Nancy Norris
Marti Norton
James Nottage
Terry O'Connor
Sherman O'Hara
Sandra Oliver
Susan Olmstead
Steven Olsen
Audrey Janet Olson
Joel Orosz
Joanna Ownby
Patricia Pachuta
Stuart Parnes
Estella Pate
R. Eli Paul

Patricia Pauly
Janet Pawlukievicz
Thomas Payne
Sherry Peck
Polly Perkins
Allison Perkins
Nancy S. Perry
Donna Peters
Ronald Pidot
Sue Plaisance
Randy Ploog
Kathleen Plourd
Gary Plum
Ellen A. Plummer
Rick Polenek
Sandra Poneleit
Gail D. Potter
Nancy Powell
Jim Powers
Jack Pratt
Olga K. Preisner
Mary Preister
Mildred Pritchard
Jan Provenzano
Dan Provo
Pat Purnell
David Raboy
Patricia P. Rachels
Keith Ragone
John Rawlins
Michael Ray
Jeffrey Ray
Kurt Redborg
Richard Redding
Mark Reed
Joseph Reeves
Gene Roberts
Robin Roberts
Thom Roberts
Jean Robertson
Elizabeth Roessel
Rebecca Rogers

Marcy Rogge
Syer Rogstad
Phyllis Rollins
Roger Rose
Richard Rosentreter
Les Roundstream
Jill Rullkoetter
Giles Runeckles
John Rychtarik
Susan Salazar
Pam Sapienza
Jeffrey Saunders
Scott Schrage
Allen Schroeder
Cynthia Schubert
Christopher Schuberth
Carol Schwarting
Tony Schwinghamer
Catherine Scott
Paul Scott
Carolyn Sechnick
James Senior
Susan Shaffer
Carol B. Shannon
Julie P. Shaw
Beverly Black Sheppard
Helen Sheridan
Susan Sherrard
Katherine Shouts
Edward Shurbutt
Kathleen Sider
Lucinda Simmons-Bray
James Sims
Arn Slettebak
Charles Smart
Ray Smenner
Bill Somers
Deborah Souvinee
Mary Speer
Ted Spellmire

Richard Spencer
Steven Spencer
Helen Springall
Robert Stark
Michelle Starr
Bonnie Stauffacher
Peter Steele
Linda Steigleder
Chris Steiner
A. T. Stevens
Geoff Stewart
Nancy Stueber
Martha Suter
Ann Suttle
Mary Suzor
Elaine Svezia-Beckman
Jeff Swanagan
Thomas H. Swearingen
Chris Sweda
Janet Sweeting
Sue Swenson
Cavett Taff
Sonnet Takahisa
Susan Talbot-Stanaway
Sandy Tanck
Betty Teller
D. Jane Thomason
Jennifer Thompson
Ruth Thompson
Thomas Thompson
Susan Tillett
Peggy Tolbert
Dan Tomberlin
Sandra Toombs
Paula Touhey
Josephine Tourais
Terri Trupiano
Valerie Tvrdik
Carl Ulanowicz
Becky Urbanski-Junker
Pierrette Van Cleve

Nancy Van Roessel
Cynthia Vernon
Lucy Voorhees
Susan Voss
John Wade
Ann Walka
Susan Walsh
Clare Weber
Ronald Weinstein
Errol White
Marcia White-Wise
Dot Wilbur
Ralph Wilke
Denice Wilkins
Mary Wilkinson
Kevin Williams
Patterson Williams
Randolph Williams
Roger Williams
Sally Williams
Susan Williams
Nancy Wilson
Sue Winder
Gary Wingert
Barbara Winter
Gail Winterman
Walter Wisura
Wally Wolfe
Robert Wolk
Robert Woltman
Mary Louise Wood
Cathy Wood
Mary Worthington
Jeannie Wray
Vince Yannie
Jeffrey J. York
Jann Young
Kerry Zack
Terry Zeller
Dennis E. Zembower
Maryjo Zunk
Kay Zuris

Further Reading

There is a growing number of bibliographies on nearly every aspect of museology: education, visitor studies, exhibition, conservation, and so forth. Particularly thorough listings have been assembled by Chandler Screven and the International Laboratory for Visitor Studies (on educational evaluation and research in museums and exhibits), and by John F. Kennedy University's Center for Museum Studies (*Museum Studies Library Shelf List*, which covers a full range of topics).

Because there are good bibliographies already in circulation, this compilation makes no attempt to be comprehensive. Its purpose is twofold: to list works that were particularly helpful or provocative to this publications' authors and contributors, and to point out some of the more academic articles and books that seldom appear on museological reading lists. Some of the critical literature that has emerged from the so-called postmodern movement, for example, is pointedly directed at museums and marks one of few instances where scholars have taken museums as an object of study and critique.

Institutional Mission

American Association of Museums. *Museums for a New Century*. Washington, D.C.: American Association of Museums, 1984.

Benjamin, Walter. "The Work of Art in an Age of Mechanical Reproduction." In *Illuminations*. New York: Schocken Books, 1969.

Bourdieu, Pierre. "Cultural Reproduction and Social Reproduction." In *Knowledge, Education, and Cultural Change*. Edited by Richard Brown. London: Tavistock, 1974.

Crimp, Douglas. "On the Museum's Ruins." In *The Anti-Aesthetic: Essays on Postmodern Culture*. Edited by Hal Foster. Port Townsend, Wash.: Bay Press, 1983.

Debord, Guy. *Society of the Spectacle*. Detroit: Black & Red, 1977.

Dimaggio, Paul. "When the 'Profit' is Quality: Cultural Institutions in the Marketplace." *Museum News* 63, no. 5 (June 1985), p. 28 - 35.

Eco, Umberto. "Travels in Hyperreality." In *Travels in Hyperreality*. Translated by William Weaver. New York: Harcourt Brace Jovanovich, 1986.

Ferguson, Marilyn. *The Aquarian Conspiracy: Personal and Social Transformation in the 1980s*. Los Angeles: J. P. Tarcher, 1980.

Gehlen, Arnold. *Man in the Age of Technology*. New York: Columbia University Press, 1980.

Harris, Neil. "A Historical Perspective on Museum Advocacy." *Museum News* 59, no. 2 (November/December 1980), p. 60 - 86.

————. "Museums, Merchandising, and Popular Taste." In *Material Culture and the Study of American Life*. Edited by Ian M. G. Quimby. New York: W.W. Norton, 1978.

Hudson, Kenneth. *Museums for the 1980s: A Survey of World Trends*. New York: Holmes & Meier Publishers, 1977.

——————. *Museums of Influence.* Cambridge: Cambridge University Press, 1987.

Lord, Barry, and Lord, Gail Dexter. *Planning Our Museums.* Ottawa: National Museums of Canada, 1983.

Lyotard, Jean-Francois. "Answering the Question: What is Postmodernism?" Translated by Regis Durand. In *The Postmodern Condition: A Report on Knowledge.* Translated by Geoff Benington and Brian Massumi. Minneapolis: University of Minnesota Press, 1984.

MacCannell, Dean. *The Tourist: A New Theory of the Leisure Class.* New York: Schocken Books, 1976.

McLuhan, Marshall. *Understanding Media: The Extensions of Man.* New York: Signet, 1964.

Montaner, Josep, and Oliveras, Jordi. *The Museums of the Last Generation.* New York: St. Martin's Press, 1986.

Rajchman, John. "The Postmodern Museum." *Art in America* (October 1985), p. 110 - 117, 171.

Susman, Warren I. *Culture as History: The Transformation of American Society in the Twentieth Century.* New York: Pantheon, 1984.

Taylor, Lonn, ed. A Common Agenda for History Museums. Nashville, Tenn.: American Association for State and Local History, 1987.

Wittlin, Alma S. *Museums: In Search of a Usable Future.* Cambridge, Mass.: MIT Press, 1970.

The Unique Potential of Objects

Barthes, Roland. "Myth Today." In *Mythologies.* London: Jonathan Cape Ltd., 1972.

Blonsky, Marshall, ed. "Introduction: The Agony of Semiotics." In *On Signs.* Baltimore: Johns Hopkins University Press, 1985.

Csikszentmihalyi, Mihaly, and Rochberg-Halton, Eugene. *The Meaning of Things: Domestic Symbols and the Self.* Cambridge: Cambridge University Press, 1981.

Culler, Jonathan. "In Pursuit of Signs." *Daedalus* 106, no. 4 (Fall 1977), p. 95 - 111.

Deetz, James. *In Small Things Forgotten: The Archaeology of Early American Life.* New York: Doubleday, 1977.

Foucault, Michel. *The Order of Things.* New York: Vintage Books, 1973.

Freeman, Ruth. *In the Mind's Eye: Examining Artifacts.* Ottawa: Royal Ontario Museum, 1987.

Hawkes, Terrence. *Structuralism and Semiotics.* Berkeley: University of California Press, 1977.

Reque, Barbara. "From Object to Idea." *Museum News* 56, no. 3 (January/February 1978), p. 45 - 47.

Schlereth, Thomas J. "Causing Conflict, Doing Violence." *Museum News* 63, no. 1 (October 1984), p. 45 - 52.

Shuh, John Henniger. "Teaching Yourself to Teach With Objects." *Journal of Museum Education* 7, no. 4 (1982), p. 8 - 14.

Stocking, George, ed. *Objects and Others.* Madison: University of Wisconsin Press, 1985.

Times Literary Supplement, October 5 and 12, 1973. Two issues devoted to semiotics.

Voris, Helen; Sedzielarz, Maija; and Blackmon, Carolyn. *Teach the Mind, Touch the Spirit: A Guide to Focused Field Trips.* Chicago: Field Museum of Natural History, 1986.

Williams, Patterson B. "Object Contemplation: Theory into Practice." *Journal of Museum Education* 9, no. 1 (1984), p. 10 - 14, 22.

————. "Object-Oriented Learning in Art Museums." *Journal of Museum Education* 7, no. 2 (1982), p. 12 - 15.

Visitor Experience

Bardt-Pellerin, Elisabeth. *A Museum Guide for Parents of Curious Children: Learning Together From Objects.* Montreal: Montreal Museum of Fine Arts, 1986.

Bennett, William J. *First Lessons: A Report on Elementary Education in America.* Washington, D.C.: U.S. Department of Education, 1986.

Boyle, Patrick G. *Planning Better Programs.* New York: McGraw-Hill, 1981.

Bruner, Jerome. *Beyond the Information Given: Studies in the Psychology of Knowing.* Edited by Jeremy M. Anglin. New York: W. W. Norton, 1973.

————. *The Process of Education.* Cambridge, Mass.: Harvard University Press, 1960.

————. *The Relevance of Education.* New York: W. W. Norton, 1971.

Cameron, Duncan F. "A Viewpoint: The Museum as a Communication System and Its Implications for Museum Education." *Curator* 11, no. 1 (1968), p. 33 - 40.

Chapman, Laura H. "The Future and Museum Education." *Museum News* 60, no. 6 (July/August 1982), p. 48 - 56.

Collins, Zipporah W., ed. *Museums, Adults, and the Humanities: A Guide for Educational Programming.* Washington D. C.: American Association of Museums, 1981.

Chase, Richard A. "Museums as Learning Environments." *Museum News* 54, no. 1 (September/October 1975), p. 37 - 43.

Cheney, Lynne V. *America's Memory: A Report on the Humanities in America's Schools.* Washington, D.C.: National Endowment for the Humanities, 1987.

Cremin, Lawrence A. "The Dilemmas of Popularization." In *American Education: The National Experience 1783-1876, Vol. II.* New York: Harper & Row, 1982.

Cross, K. Patricia. *Adults As Learners.* San Francisco: Jossey-Bass, 1981.

Czikszentmihalyi, Mihaly. *Beyond Boredom and Anxiety.* San Francisco: Jossey-Bass, 1975.

Dewey, John. *Art as Experience*. New York: Minton, Balch, 1934.

————. *The Child and the Curriculum* and *The School and Society* (one volume). Chicago: University of Chicago Press, 1956.

Draper, Linda, ed. *The Visitor and the Museum*. Washington, D.C.: American Association of Museums, Education Committee, 1977.

Draves, William A. *How to Teach Adults*. Manhattan, Kans.: Learning Resources Network, 1984.

Gardner, Howard. *Frames of Mind*. New York: Basic Books, 1983.

Hood, Marilyn G. "Staying Away: Why People Choose Not to Visit Museums." *Museum News* 61, no. 4 (April 1983), p. 50 - 57.

Houle, Cyril O. *The Design of Education*. San Francisco: Jossey-Bass, 1972.

Jensen, Nina, et al. "Children, Teenagers, and Adults in Museums: A Developmental Perspective." *Museum News* 60, no. 5 (May/June 1982), p. 25 - 30.

Knez, I.E., and Wright, A.G. "The Museum as a Communications System: An Assessment of Cameron's Viewpoint." *Curator* 13, no. 3 (1970), p. 204 - 212.

Lewis, B. N. "The Museum as an Educational Facility." *Museums Journal* 80, no. 3 (1980), p. 151 - 155.

Museum News 65, no. 2 (December 1986). Entire issue devoted to museum education.

National Commission on Excellence in Education. *A Nation at Risk: The Imperative for Educational Reform*. Washington D.C.: U. S. Government Printing Office, 1983.

National Science Board Commission on Precollege Education in Mathematics, Science and Technology. *Educating Americans for the Twenty-First Century*. Washington D.C.: National Science Foundation, 1983.

Newsom, Barbara Y., and Silver, Adele Z., eds. *The Art Museum as Educator*. Berkeley: University of California Press, 1978.

Nichols, Susan; Alexander, Mary; and Yellis, Ken, eds. *Museum Education Anthology*. Washington, D.C.: Museum Education Roundtable, 1984.

Schools Council (of Great Britain). "Forward Looking." In *Pterodactyls and Old Lace: Museums in Education*. Norwich, England: Fletcher and Son, Ltd., 1972.

Scribner, Sylvia, and Cole, Michael. "Cognitive Consequences of Formal and Informal Education." *Science* 182, no. 4112 (November 9, 1973), p. 553 - 559.

Stapp, Carol B. "Defining Museum Literacy." *Journal of Museum Education* 9, no. 1 (1984), p. 3 - 4.

Washburn, Wilcomb. "Do Museums Educate?" *Curator* 18, no. 3 (1975), p. 211 - 218.

Staff: Interpretation Through Exhibits and Programs

American Association of Museums Committee on Ethics. *Museum Ethics*. Washington D.C.: American Association of Museums, 1978.

Baudrillard, Jean. "The Precession of Simulacra." In *Art After Modernism: Rethinking Representation*, edited by Brian Wallis. New York: New Museum of Contemporary Art, 1986.

Benson, Susan Porter; Brier, Stephen; and Rosenzweig, Roy. *Presenting the Past: Essays on History and the Public*. Philadelphia: Temple University Press, 1986.

Bradford, Leland. *Making Meetings Work*. San Diego: University Associates, 1976.

Carson, Barbara G., and Carson, Cary. "Things Unspoken: Learning Social History from Artifacts." In *Ordinary People and Everyday Life: Perspectives on the New Social History*. Edited by James B. Gardner and George Rollie Adams. Nashville, Tenn.: American Association for State and Local History, 1983.

Donato, Eugenio. "The Museum's Furnace: Notes Towards a Contextual Reading of *Bouvard and Pecuchet*." In *Textual Strategies: Perspectives in Post-Structuralist Criticism*. Edited by Josue V. Harari. Ithaca: Cornell University Press, 1979.

Duncan, Carol, and Wallach, Alan. "The Museum of Modern Art as Late Capitalist Ritual: An Iconographic Analysis." *Marxist Perspectives* 1, no. 4 (Winter 1978), p. 28 - 51.

Eisner, Elliot W., and Dobbs, Stephen M. *The Uncertain Profession: Observations on the State of Museum Education in Twenty American Art Museums*. Los Angeles: Getty Center for Education in the Arts, 1986. Unpublished report on a study.

Grinder, Alison, and McCoy, Sue. *The Good Guide: A Sourcebook for Interpreters, Docents, and Tour Guides*. Scottsdale, Ariz.: Ironwood Press, 1985.

Haraway, Donna. "Teddy Bear Patriarchy: Taxidermy in the Garden of Eden, New York City, 1908-1936." *Social Text* (Winter 1984), p. 20 - 64.

Harbison, Robert. *Eccentric Spaces*. New York: Alfred A. Knopf, 1977.

Hord, S.M., et al. *Taking Charge of Change*. Alexandria, VA: Association for Supervision and Curriculum Development, 1987.

Horowitz, Helen. "Animal and Man in the New York Zoological Garden." *New York History* 61 no. 4, (1975), p. 426 - 455.

Knox, Alan B. *Leadership Strategies for Meeting New Challenges*. New Directions for Continuing Education Series, no. 13. San Francisco: Jossey-Bass, 1982.

Kuhmerker, Lisa, ed. "The Socio-Moral Dimension of Museum Design." *Moral Education Forum* 10, nos. 3 and 4 (Fall/Winter 1985), entire issue.

Malraux, Andre. *Museum without Walls.* New York: Doubleday, 1953.

Manar, Hammad. "A Semiotic Reading of a Museum." *Museum* 39, no. 2 (1987), p. 56 - 60.

McLuhan, Marshall; Barzun, Jacques; and Parker, Harley. *Exploration of the Ways, Means and Values of Museum Communication With the Visiting Public.* New York: Museum of the City of New York, 1969.

Meltzer, David. "Ideology and Material Culture." In *Modern Material Culture: The Archaeology of the United States.* Edited by Richard A. Gould and Michael Schiffer. New York: Academy Press, 1981.

Munley, Mary Ellen. *Catalysts for Change: The Kellogg Projects in Museum Education.* Washington, D.C., Chicago, and San Francisco: Kellogg Projects in Museum Education, 1986.

O'Doherty, Brian. *Inside the White Cube: The Ideology of the Gallery Space.* San Francisco: Lapis Press, 1986.

Peters, Thomas, and Austin, Nancy. *Passion for Excellence.* New York: Random House, 1985.

Peters, Thomas, and Waterman, Robert. *In Search of Excellence.* New York: Harper and Row, 1982.

Rapoport, Amos. *The Meaning of the Built Environment: A Nonverbal Communication Approach.* New York: Sage Publications, 1982.

Rumelhart, David E. "Schemata: The Building Blocks of Cognition." In *Theoretical Issues in Reading Comprehension.* Edited by Rand J. Spiro, Bertram C. Bruce, and William F. Brewer. Hillsdale, N.J.: Lawrence Erlbaum Associates, 1980.

Schlereth, Thomas J. "Object Knowledge: Every Museum Visitor an Interpreter." *Journal of Museum Education* 9, no. 1 (1984), p. 5 -9.

——— *Artifacts and the American Past.* Nashville, Tenn.: American Association for State and Local History, 1980.

Schroeder, Fred. *Seven Ways to Look at an Artifact.* Technical Leaflet 91. Nashville: American Association for State and Local History.

Skramstad, Harold K. "Interpreting Material Culture: A View from the Other Side of the Glass." In *Material Culture and the Study of American Life.* Edited by Ian M. G. Quimby. New York: Norton, 1978.

Stewart, Susan. *On Longing: Narratives of the Miniature, the Gigantic, the Souvenir, the Collection.* Baltimore: Johns Hopkins University Press, 1984.

Tilden, Freeman. *Interpreting Our Heritage.* Chapel Hill, N.C.: University of North Carolina Press, 1977.

Wittlin, Alma S. "Interpretations and Misinterpretations." In *Museums and Education.* Edited by Eric Larrabee. Washington D.C.: Smithsonian Institution, 1968.

Evaluation

Bogdan, R.C., and Biklen, S.K. *Qualitative Research for Education: An Introduction to Theory and Methods.* Boston: Allyn and Bacon, 1982.

Cameron, Duncan, and Abbey, D. "Museum Audience Research." *Museum News* 40, no. 2 (October 1961), p. 34 - 38.

Journal of Museum Education 7, no. 4 (1982). Issue devoted to language and methodology for research.

Journal of Museum Education 8, no. 2 (1983). Issue devoted to visitor behavior studies and strategies.

Journal of Museum Education 12, no. 1 (1987). Issue devoted to evaluation.

Loomis, Ross J. *Museum Visitor Evaluation: New Tool for Management.* Nashville, Tenn.: American Association for State and Local History, 1987.

Melton, Arthur. "Visitor Behavior in Museums: Some Early Research in Environmental Design." *Human Factors* 14, no. 5 (October 1973), p. 393 - 403.

Miles, R.S., et al. *The Design of Educational Exhibits.* London: Allen and Unwin Publishers, 1982.

Museum News 65, no. 3 (February 1986). Entire issue devoted to role of evaluation in museums.

Popham, W. James. *Educational Evaluation.* Englewood Cliffs, N.J.: Prentice-Hall, 1975.

Robinson, Edward S. *The Behavior of Museum Visitors.* Washington D.C.: American Association of Museums, 1928.

Screven, Chandler. "Exhibit Evaluation: A Goal-Referenced Approach." *Curator* 19, no. 4 (1976), p. 271 - 290.

————. "Exhibitions and Information Centers: Principles and Approaches." *Curator* 29, no. 2 (1986), p. 109 - 137.

Weiss, Carol H. *Evaluation Research.* Methods of Social Science Series. Englewood Cliffs, N.J.: Prentiss-Hall, 1972.

Wolf, Robert L. "A Naturalistic View of Evaluation." *Museum News* 58, no. 6 (July/August 1980), p. 39 - 45.

————, and Tymitz, Barbara L. "A Preliminary Guide for Conducting Naturalistic Evaluation in Studying Museum Environments." Washington, D.C.: Office of Museum Programs, Smithsonian Institution, 1979.Captions for Kellogg Publication Illustrations

Whitehead, Alfred North. *The Aims of Education and Other Essays.* New York: Free Press, 1967.

Wittlin, Alma S. *The Museum: Its History and Its Tasks in Education.* London: Routledge and Kegan-Paul, 1949.